DRAWING FLOWERS

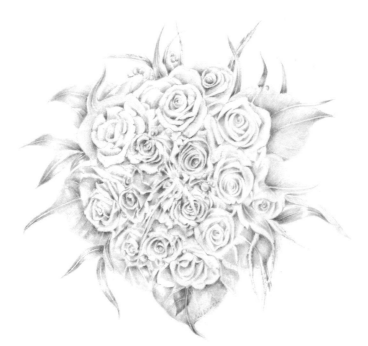

DRAWING FLOWERS

CREATE BEAUTIFUL ARTWORKS WITH THIS STEP-BY-STEP GUIDE

JILL WINCH

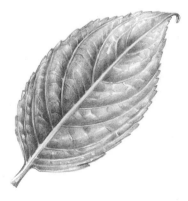

ARCTURUS

LONDON BOROUGH OF WANDSWORTH	
9030 00003 8714 5	
Askews & Holts	05-Jun-2014
743.73	£7.99
	WWX0012315/0119

ARCTURUS

This edition published in 2014 by Arcturus Publishing Limited
26/27 Bickels Yard, 151–153 Bermondsey Street,
London SE1 3HA

ISBN: 978-1-78212-625-6
AD003868UK

Printed in China

Contents

Introduction

Drawing has always been a passion of mine; for as long as I can remember it has been important to me. However, it was only in later years, when I discovered botanical art and an inspirational teacher to guide me, that it grew into a love that would become part of my daily life. Encouraged by a lovely supportive family, I was fortunate to be able to follow my dream.

This book is a wonderful opportunity for me to pass on the knowledge and experience I have gained, not only through years of drawing but also from teaching – knowing what is required to give someone the confidence to put pencil to paper and take them through the fundamentals of drawing. The book is designed for everyone, from the beginner to the more experienced. I hope to encourage the beginner to start drawing and inspire the more experienced artist to continue with the study of this fascinating topic.

There is so much to learn from the study of flowers, and this book will take you on a journey on which you will not only look at how to draw the petals and leaves of the flower, but also bulbs, roots and the glorious seed heads that emerge at the end of the flowering season.

Drawing is not a mystery known only to some and eluding others. Through continual practice and breaking down the process into small elements that make up the whole, you will find success – and the drawing of flowers is a magical way of learning.

Jill Winch

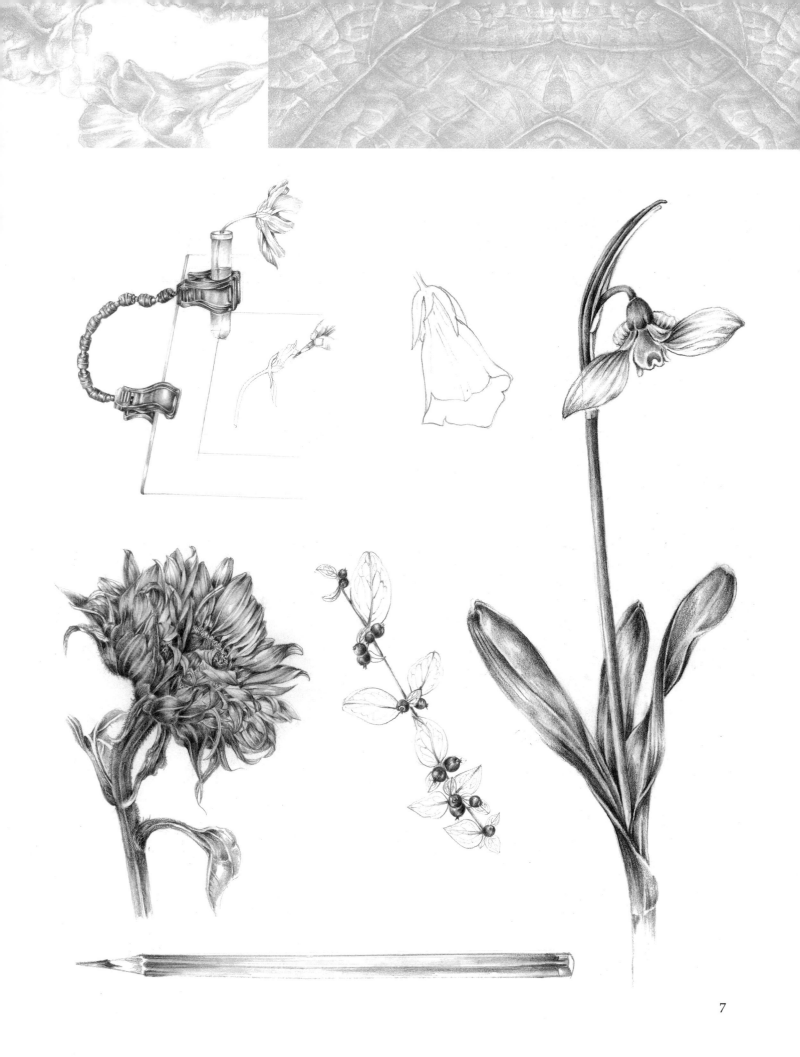

Chapter 1
Getting started

In this chapter, we look at the equipment you need in order to embark on your flower drawing. Most of us, when we're learning a new skill, will often buy too many materials at the outset through sheer enthusiasm, but this is often a waste of money. All that's necessary to make a start here is a pencil, a sharpener, an eraser and some paper.

With any materials, I strongly advise trying products from several manufacturers, since one brand's 2H pencil will certainly be different from another, for example. I have discovered my own preferences over the years mainly by exploring what's available from art supplies stockists rather than by following recommendations from other artists.

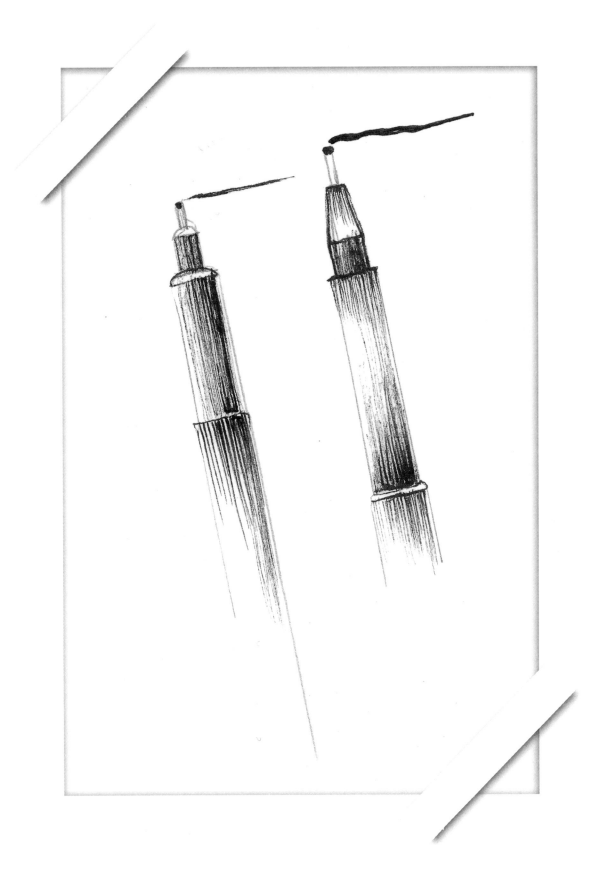

Pencils and accessories

While brands differ slightly in the range they offer, pencils are graded from 9H through to 9B, 9H being the hardest and 9B the softest, with HB and F in between. The H pencils can produce lovely light tones; for the darker shadow areas, I often use the softer B grades. The addition of small, intense areas of dark shading, made with a B pencil sharpened to a fine point with an emery board, can create instant drama in your drawing. Derwent, Faber-Castell and Staedtler are excellent manufacturers and you can buy a box with a good range of hard and soft leads. You can give the pencil lead an angled edge by using an emery board, which will enable you to produce both tone and very fine line.

9H ← - → H

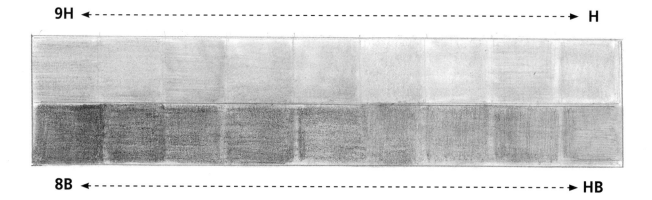

8B ← - → HB

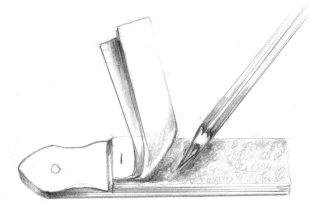

Clutch pencils are versatile and useful as you can expose the lead to the required length and grind it to a fine point, again with an emery board. These pencils sometimes have a removable sharpener at the end. Use this with caution, as the fine graphite dust can sometimes remain in the sharpener and spill out on to your paper. The leads are quite thick – usually 2–5mm. When you want a harder or a softer lead, change it by inserting it into the clutch mechanism at the tip.

A propelling pencil differs from a clutch pencil in that the leads used are usually finer at 0.3mm, 0.5mm and 0.7mm, and you simply push the end of the casing to propel the lead forwards. These pencils can be used for fine, detailed work, but the lead is susceptible to snapping if you exert much pressure. There's no need to sharpen it, as movement on the paper will produce the smooth edge that is required.

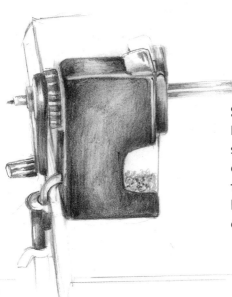

Sharpeners

Desk sharpeners can be clamped to the table surface, which makes them look sturdy and capable. However, they can sometimes make the lead in the pencil unstable, so the simple hand-held pencil sharpeners are not only a cheaper alternative but better, too.

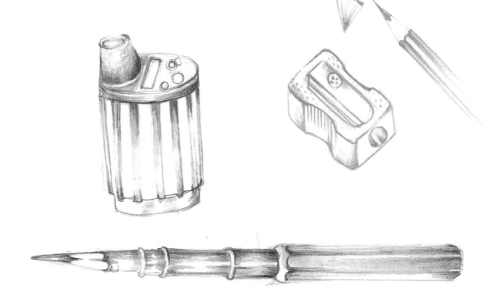

With repeated sharpening your pencils will become shorter, of course. A pencil extender is a handy tool which lengthens the barrel to give you extra grip and so prolongs the life of the pencil.

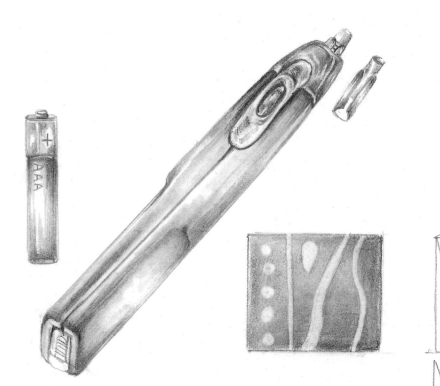

Erasers

A battery-operated eraser is a useful tool for taking out specific marks, as it revolves at quite a high speed and is firm and small.

A putty rubber is very pliable and ideal for lifting out highlights and overworked parts. You can break off bits with which to lift out specific small areas – this is a more gentle approach than using a battery-operated eraser, but it is less effective for restoring the white of the paper. It's also possible to roll a piece of putty rubber into a sausage shape and glide it over the paper – this avoids disturbing the surface by rubbing. Alternatively, to lift out finer lines, use a scalpel to cut angled slices from a plastic eraser.

Tortillons and paper stumps

Made from tightly rolled paper, tortillons and paper stumps are designed for smoothing areas of graphite to give a smudged look, or spreading the graphite to give an area of overall tone. There is little difference between them, though you have a choice between one pointed end or points at both ends. They can be cleaned by rubbing the end with some fine sandpaper, which also restores a fine point. Tortillons and paper stumps are available in a variety of sizes from quite small to large.

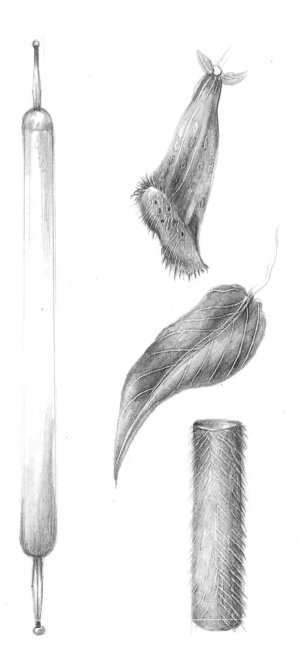

Stylus

I use this tool for indenting the paper, which is a good way of creating hairs on stems, leaves and petals (see pages 98–99). Styluses have wooden stems, with different-sized metal ends in the shape of a ball. For a much finer line, you could use a darning needle or any metal implement with a blunt end.

Pen and ink

For pen-and-ink work, the most useful and easily available tools are fibre-tip pens. Often described as throwaway pens, they are an economical purchase. Depending on the manufacturer, they can be bought in various sizes. For the finer line shown here, I used a Staedtler 0.05, a pen with lightfast, waterproof ink. For the thicker line, I used a Staedtler 0.3 pen. I would generally not use a nib bigger than 0.3 for flower drawing. It is worth experimenting with different makes, such as Pilot, Edding and Faber-Castell.

Another useful tool for pen-and-ink work is a mapping pen, a favourite of mine as it gives a very fine line, especially when you use the reverse of the nib. Lots of practice is recommended for this, but once you master a mapping pen it's an excellent device. It's best to apply ink to the top of the nib with a pipette or brush rather than dipping it into a bottle of ink, as this avoids overloading the pen and causing unnecessary blobs on your work. Take care of the nib and make sure it's thoroughly washed after use, as dried ink residue can split it.

For pen and wash, a water-soluble ink is needed. The pen I use is a Rotring Rollerpoint. It's more than 40 years old and still working well! After line drawing with the pen, I wash the ink across the image using a brush and some water.

Paper

Paper is available with three different surface textures: Hot Pressed (HP), which is nearly smooth; Cold Pressed, or Not, which has more texture; and Rough, the most textured. I generally use a Hot Pressed paper, which is good for both drawing and painting. I find the texture of Not paper unsuitable for pencil drawings of flowers; Rough is obviously even less suitable.

You can buy Hot Pressed paper in separate sheets or in pad form; the advantage of the former is that you can cut it to your required size. I have used Fabriano Classico 5 Hot Pressed paper, which is pure white, for the drawings in this book. Other Hot Pressed papers such as Fabriano Artistico and Arches are a little more creamy, and although these are lovely to use they are not always ideal for flower drawing, where the white of the paper plays an important part. Another possibility is Bristol board, a heavy paper popular for pen-and-ink work as it has a totally smooth surface which eliminates dragging when you are using nib-type pens.

Paper comes in different weights, suitable for different purposes. A medium-heavy paper of 300gsm (140lb) is an ideal weight to use. I find a lighter 200gsm (90lb) paper slightly too flimsy, while a heavier 600gsm (280lb) is unnecessary for pencil drawing.

When it comes to choosing the sizes of paper you want, you can see from the diagram that there is a simple logic to the way they are described. An A3 sheet is two A4 sheets of paper, side by side. An A2 sheet measures four x A4, and an A1 sheet is eight x A4.

Using tracing paper

If you're new to flower drawing, I suggest working on tracing paper first. You can erase mistakes as many times as you like on tracing paper without spoiling the surface, then when you're happy with your drawing you can transfer it to your Hot Pressed paper. I often use a well-lit window to do this, placing the tracing paper against the window and the Hot Pressed paper on top. The image can clearly be seen through the paper and you can trace your design with a light pencil. Sometimes I will go over the drawing on tracing paper with pen and ink. The tracing-paper drawings can be re-used to create new compositions (see page 108).

Alternatively, you can use a lightbox to transfer your drawing – there's now a good range on the market. The basic principle is the same, but you may find it easier to draw on a horizontal surface than on a vertical window.

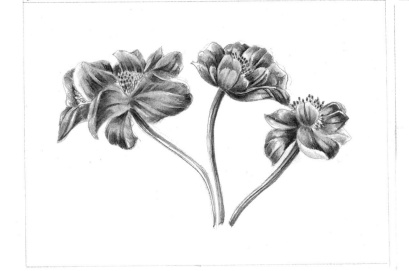

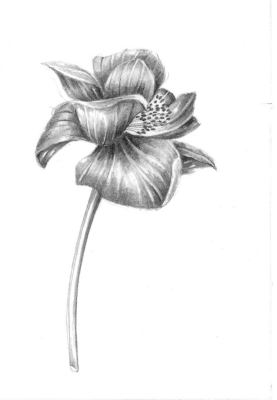

Format

You can choose which way round you use your rectangular sheet of paper. To draw a single flower, or even two or three grouped together, I tend to use a portrait (vertical) format. For a wider composition, a landscape (horizontal) format may be more suitable. It's a good idea to place the paper behind your subject to see what would look best before you start.

Practicalities

You'll need a range of accessories to help with your flower drawing. Most of them are fairly inexpensive and you may already have some of them around the house.

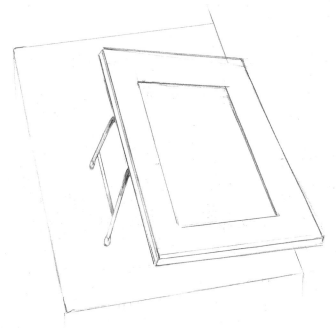

Drawing boards

For flower drawing I prefer to use a drawing board with a fold-down stand. This one is lightweight with a stand that doubles as a handle, useful for transporting. I find an A2 board convenient for all the sizes of paper I use, and the stands, one on a short side and another on a long side, enable me to turn the board for either portrait or landscape formats.

Another good alternative is a wooden drawing board (below). This has several options for varying the angle for working and it folds flat for transportation. I find it best to place a piece of A3-sized MDF (medium-density fibreboard) on this drawing board, as it has no solid back, and to fix the paper to it. I tend to use a small piece of putty rubber for this, attaching it to the back of the paper so that it can be lifted easily.

The least expensive option for a drawing board is to use a piece of MDF cut to the required size and to angle it by resting it on something soft – a kitchen roll, or a small bolster-shaped cushion, is ideal.

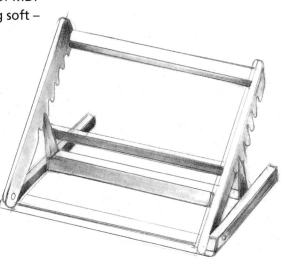

The angle you work at will help with your posture. Leaning over a flat board can cause unnecessary strain to the back of the neck, so it's important to avoid this. Try not to sit for too long – make a point of stopping often for small breaks to walk around and take deep breaths – since there is a tendency to breathe shallowly when concentrating. I do find that the concentration required can be very relaxing, like a type of meditation, so you could say that from a health point of view, flower drawing is good for you!

Holders for flowers

Clear glass containers are ideal for flower stems. There's no need to go to great expense as suitable containers can be found in most homes – for example, an olive oil or wine bottle, washed out, can be a great addition to your collection. Smaller containers such as the posy bowl in this illustration can be used for daintier flowers such as violas or sweet peas.

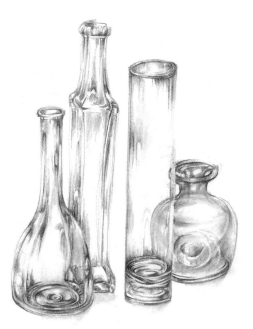

Orchid holders can be obtained from your local florist – most florists will gladly give them away – and they will hold stems of various kinds. They have a removable rubber top with a hole in the centre, usually wide enough for a single stem. Thick stems such as those of sunflowers are best placed in a glass vase and can be made stable by being wedged in with some kitchen roll between glass and stem. Alternatively, secure the stem against the glass with masking tape.

The orchid holder can be placed in a foam or floristry block for support. Alternatively, a flexible tool called a Wiggly Worm, available from photography supplies shops, is perfect for securing the orchid holder and fixing it to the drawing board. It also enables you to adjust the angle of the orchid holder containing your flower.

19

Magnifiers and microscopes

It's a useful exercise to look at your flower and leaves initially with a magnifying lens, so that you have a better understanding of the fine details of leaf veins and stamens before putting pencil to paper. Making separate studies from the magnification can be an aid to your final drawing.

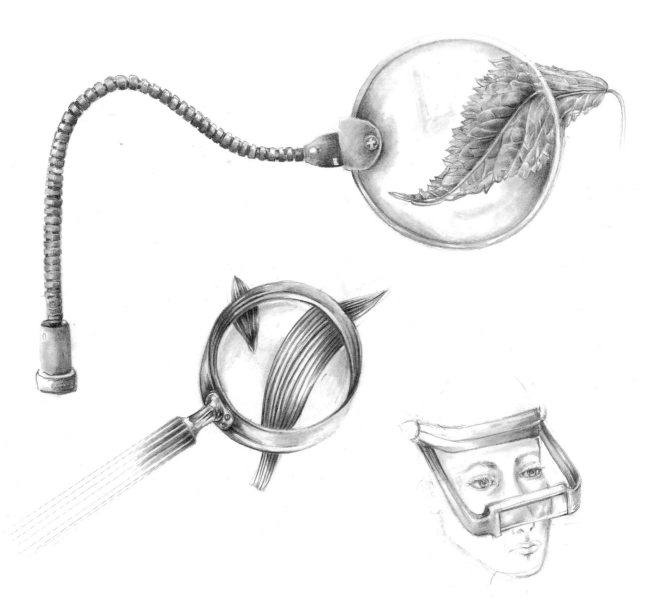

A range of magnifiers can be found, from table-top, with or without a light, to hand-held or headband magnifiers. Table magnifiers usually have a flexible arm and can either be clamped to the desk or attached to a stand. My own preference is for headband magnifers, as they are comfortable to use and have the advantage of leaving both hands free. They come in various styles, with adjustable lenses to suit your vision.

Microscope

A microscope will allow you to see in even greater detail than a magnifier and is particularly useful for viewing your flower after you have dissected it with a scalpel, giving you an even greater understanding of its structure. Although a microscope isn't essential and makes an expensive addition to your equipment list, you may find that the true wonder of seeing parts of your flower magnified to this degree makes buying one worth the expense.

Proportional dividers

For scaling up a drawing of a flower to make it larger than life, you will find proportional dividers invaluable. They are often used in microscope work, where the flower parts are drawn at a much larger scale. By changing the settings on the dividers you can show your drawings as x2, x3, or greater. For this drawing the setting was x2, so that when the petal was measured with one end of the dividers, the other end gave a measurement exactly twice the size. An example of this degree of enlargement is shown with the drawn petal.

Lighting

Daylight is the best form of light for drawing, but in its absence daylight lamps are a good alternative, giving illumination close to natural daylight. I have two daylight lamps – an angled-arm one that can be left in my studio and a portable one that folds neatly and is easily transportable. The angled-arm design is also available with a magnifying lens, giving you everything you need in one lamp. A cheaper alternative is to buy a daylight bulb and fit it into a flexible arm lamp, as long as the wattage is suitable.

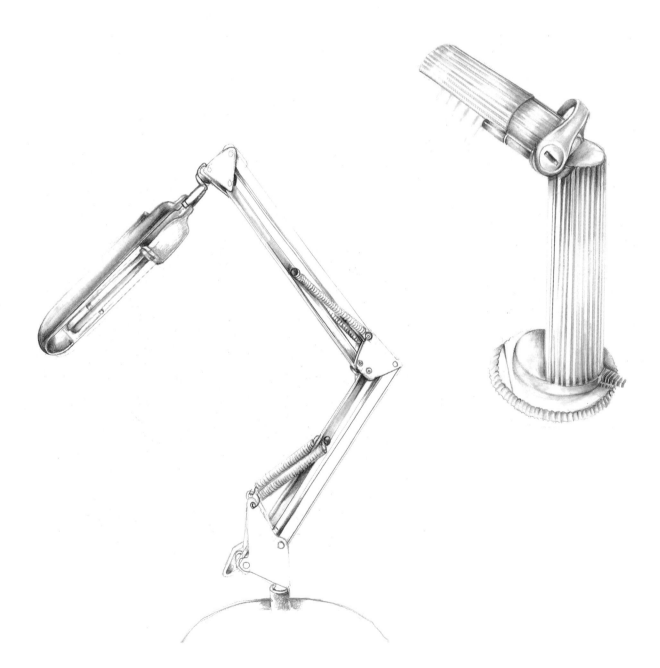

Enclosing your study with a piece of angled mountboard (see below) helps to cut out any unwanted light sources. A single light source directed on to your subject shows light and shade at their most apparent.

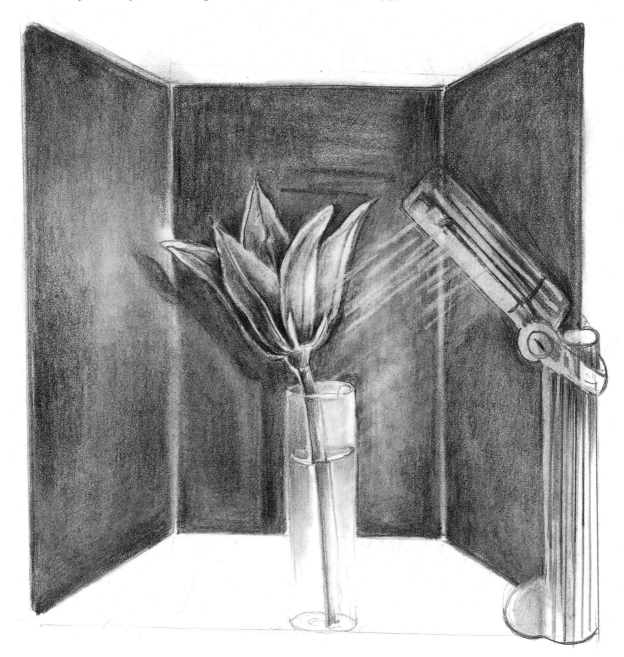

Angled mountboard

Using mountboard as a background allows you to isolate your subject. You can buy the board from your art supplier – an A2 sheet will be sufficient. Divide the width into thirds then, measuring one third in from each side, take a scalpel and scour both sides of the board from top to bottom, being careful not to go right through to the other side – you need a cut just deep enough for you to be able to bend the board. Make one mountboard in black and the other in white, so you can decide whether your study stands out best against a light or a dark background.

Chapter 2
First stages

Many people say 'I can't draw', but we can all write and we learned to do this as children, simply by practising how to control our pencils until we could make the necessary marks. Yet putting pencil to paper for the purpose of making a drawing can be quite terrifying, especially when you're trying to be accurate. Breaking down the process into manageable bites makes everything much easier and, if it's possible to do so, drawing each day to develop your skills will soon build your confidence. Recording your work in a sketchbook, so that you can see your progress, is also very encouraging.

The value of your initial observation should not be underestimated, so allow plenty of time for this, reducing your flower to simple geometric shapes to help understand its structure. Use a magnifying lens for this, or a microscope for even greater detailing. I feel that when drawing the smaller parts of a flower, such as the stamens, observing these details through magnification allows them to be lodged in the brain and makes the process easier when putting pencil to paper. What is seen with the naked eye may be misinterpreted in the initial stages of drawing – stamens are often drawn as dots, when actually they are complete shapes.

Light, an important element in flower drawing, can give life to your subject if it's used correctly. A common problem for the beginner is the interpretation of how the light falls, and sometimes it's awkwardly rendered. This is where the deployment of continuous tone can help, working from the darkest areas through to the lightest, represented by bare paper. We shall look at how this is done both with pencil and with pen and ink.

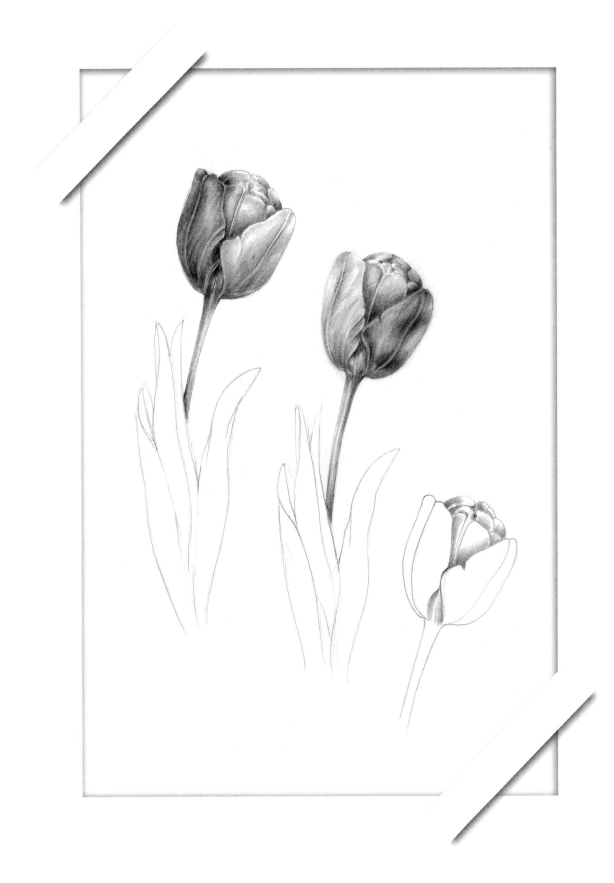

Observation and measuring

Perspective is key to creating a three-dimensional picture on a two-dimensional surface. There are two types of perspective – aerial and linear. With aerial perspective, details appear less distinct and colours less strong the further they are from your viewpoint. With linear perspective, objects appear smaller the further away they are. In botanical drawing, the effect of both types of perspective is subtle as your subjects are mostly close to your viewpoint. Nevertheless, if a flower is angled towards you, the effect will be to foreshorten it; this will compress its length and appear to enlarge the area nearest to you.

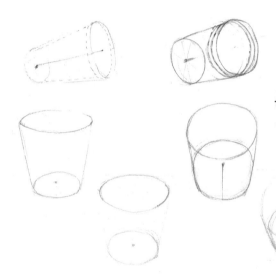

This exercise shows the different perspectives a flower head will have when you look at it from various angles. I have taken a plastic cup and marked it with a black pen at the bottom centre. This represents a flower head. As the cup is tilted, you can see how the base appears smaller and the centre point changes position. The same exercise can be done with the cup drawn from a side angle.

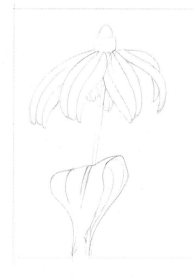

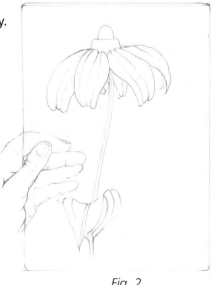

Try drawing a box as an aid to accuracy. Take a measurement of your flower to decide on the size of your study. Many students measure the total length of petals and leaves, which makes for a drawing that is out of proportion to the original (Fig. 1). Instead, have a piece of perspex or glass cut to A3 size and place it in front of your subject, at eye level. With a water-soluble pen, draw what you can see through the glass on to it. This will render your flower as a two-dimensional image (Fig. 2).

Fig. 1

Fig. 2

Start at the point where the flower touches the box on the left. Draw a horizontal line from this point and observe which petals are above and below it. As you begin to draw your flower, you will need to assess and reassess which petals are in line either on a vertical or horizontal plane. Some lines have been drawn (right) to give you an idea of how this is done. This can also be achieved with your pencil, holding it out in front of you and looking at what is in line horizontally or vertically. After a while, it will not be necessary to draw the line, as your eye will be trained for accuracy. Practise when looking at things around you during the day – have a sketchbook and pencil or pen to hand and make small sketches when you can.

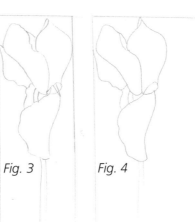

Fig. 1 *Fig. 2*

Negative space

Looking at the spaces in between and around your flower head can help you understand its structure and portray it accurately. Using two different-shaped flowers from the same plant (Figs. 1 and 2) measure the width and height and construct a box. The horizontal and vertical dotted lines show the correlation between one petal and another and enable you to draw them within the box.

Fig. 3 *Fig. 4*

I have drawn Fig. 1 twice (Figs. 3 and 4) to show how creating more negative space around the flower changes the look of the subject.

Fig. 5

In Fig. 5, the angle of the flower in Fig. 2 has been altered and the box drawn again to create a pleasing negative space to the right of the subject.

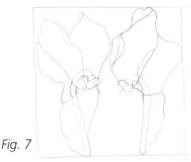

Fig. 6 *Fig. 7*

In Figs. 6 and 7, the petal shapes have been duplicated to experiment with the use of positive shapes within a space. This shows how interest can be created by the positioning of flower shapes. Experiment by drawing a simple flower shape and see how using the space around your image changes the overall feel and look of your drawing.

Initial studies

Making initial studies of flowers, from a bud through to the open flower, is a worthwhile exercise. Try to have two flowers so that you can dissect one to understand its structure. Remove the petals, noting how they attach to the stem, and see if they differ. Also observe the number of stamens and their shape and size. If you have a microscope, use it to gain as much information as possible.

Basic shapes in continuous tone

The next stage in your drawing is to practise tonal shading, or continuous tone, to show the details and shadows on a flower. The geometrical shapes on this page are often found in basic flower formations, so they're used for these simple exercises in showing light and shade by using continuous tone.

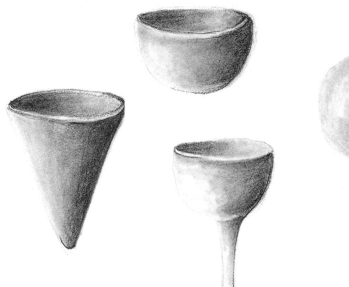

Continuous tone is the smooth, graduated effect achieved by shading in using small ellipses or circles. Practise using a fairly soft pencil and lightly work in small ellipses across a geometric shape, pressing more gently for the paler areas. I find this method preferable to shading with a line, which can cause gaps to appear in your tone. I usually start with a line drawing of my chosen subject, drawn lightly with a 2H pencil. Then I add continuous tone with the pencil, varying the pressure, moving from dark areas through to light and back again until the right level of density is achieved. I pay particular attention to the overlapping petals, creases and any definitive marks where the depth of tone will give added dimension.

The tonal strip below ranges through different pencil grades, from 7H (lightest) to 8B (darkest). It is useful as a tonal chart or as a reference to compare the light, mid-tone and dark areas of your flower. Try reproducing the chart yourself to get a feel for the different pencil strengths.

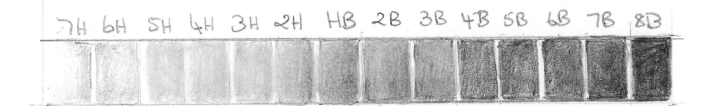

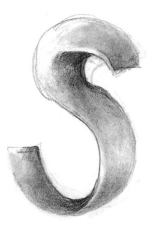

The S and ribbon shapes are examples of how to make a simple line drawing look three-dimensional by shading in the curved areas. Creating shapes like this is a fun way of experimenting with continuous tone.

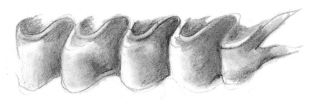

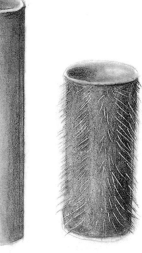

To shade these stems I worked in small ellipses, moving an HB pencil across the stem and lifting it until it hardly touched the paper in the lightest areas. Because the softer B pencils can pick up the grain of the paper, I retraced my steps with a harder pencil, a 2H, to soften the effects of the grain.

With the hairy stem, I used the same principle but initially indented the paper with a stylus. You can use any fine tool to indent – sometimes I use a darning needle for fine hairs. I used quick movements of the stylus, first pressing quite hard and then flicking my hand towards the end. This technique can be fun and we shall explore it more in the section on drawing poppies and their hairy stems (see page 98).

Lily: cone shape

My flower was positioned in front of an angled board to prevent a lot of natural light bouncing off it, and my daylight lamp was positioned to the left of the flower, creating shadow on the right-hand side. Using an HB pencil, I worked each section in small ellipses, starting from my darkest areas on the far right through to the lightest on the left. For the lightest areas I used a 2H pencil.

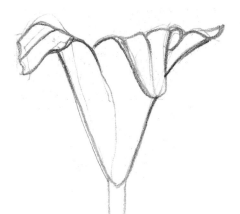

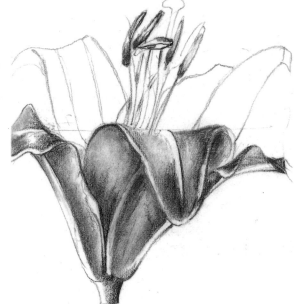

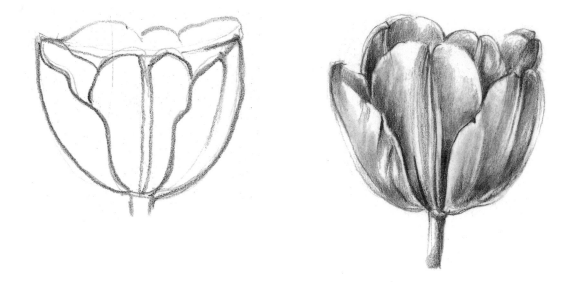

Tulip: bowl shape

The next two flower heads were rendered in much the same way. The right-hand side of the tulip was kept in shadow, as were the inside petals. I used extra tone on the left-hand petals to create the slightly creased effect and left the tops of the petals pale.

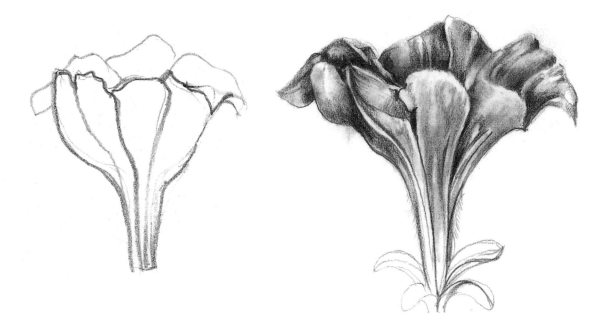

Petunia: cup shape

For the petunia, I used a sharp 7B pencil to create deep shadow for the darkest areas, a 2H pencil for the lightest, and an HB pencil for the overlapping petals. I left the curling tips of the petals pale, as the light bounced off beautifully at this point.

Continuous tone studies

Magnolia

To portray this magnolia flower, I began by making a line drawing, paying particular attention to the curve of the left outer front petal. The central vein of this petal lines up with the central vein on the inside petal. My line study has dotted lines showing the edges of the petals and the central veins that are obscured. Line drawings are useful for discovering how the petals are attached to the stem.

Finally, using a 2H pencil, I applied continuous tone to the drawing of the whole flower, adding depth with a softer HB pencil in the shadow areas. I used the same technique for the bud, but with a softer B pencil for the darker shadow areas, as the buds tend to be darker. To finish, I applied a harder 3H pencil all over the drawing of the bud to soften any grainy effects of the B pencil on the paper.

Hellebore

Here I have drawn a hellebore flower from two different angles. The first flower (Fig. 1) is shown as a basic line drawing using a circle as a guide. I reduced the size of the circle on the right-hand side of this drawing to create the cupped effect of the flower and the petals fitted within it.

Fig. 1

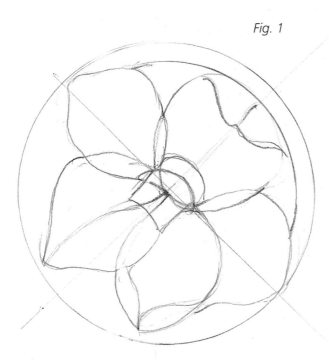

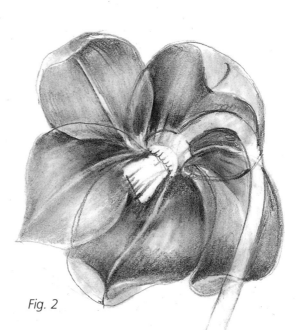

Fig. 2

Fig. 2 shows the importance of the stem and how it is attached to the flower. I have erased the tone on the stem so you can see how it would appear if visible through the petals.

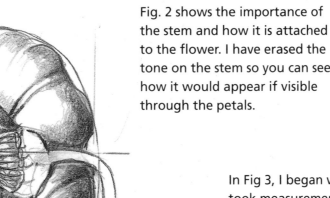

In Fig 3, I began with a circle and took measurements to show the side view and a cluster of stamens growing from the centre.

Fig. 3

Pen and ink

Using ink enables you to create strong tonal contrasts in the absence of colour. In this section we look at the different strokes that can be created, from fine and heavier lines to describe light and shade, to stippling and crosshatching.

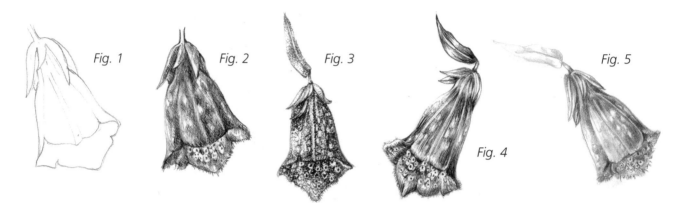

Fig. 1 *Fig. 2* *Fig. 3* *Fig. 4* *Fig. 5*

Here *Digitalis* (foxglove) flower heads are rendered in line, stippling and crosshatching to show the different effects that can be created using these techniques.

I started with a line drawing (Fig. 1) then applied tone with a pencil (Fig. 2). This indicated to me how my pen marks should be made, in a heavier or lighter application. Then, with a 0.05 fibre-tip pen, I used line in Fig. 3, stippling in Fig. 4 and crosshatching in Fig. 5. While I can't say that any one of these works better than the others, I do think the crosshatching gives a certain texture to the flower head.

On the right are practice exercises for pen techniques. Simple exercises like these will really help you to develop your drawing skill, especially if you do them often. The first box shows varying widths of line to create shading, using a mapping pen and ink. The mapping pen is an excellent tool for creating really fine lines.

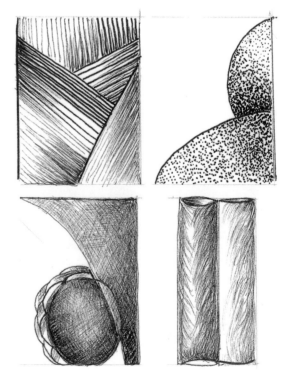

The second box shows two semi-circles with stippling. Notice how you can create a deeper shadow by intensifying the dots and placing them closer together. I used a 0.1 fibre-tip pen to create a darker mark on the paper.

In the third box, I used crosshatching. This involves crossing one line over another with a fine pen – again a mapping pen is a good choice. Crosshatching takes a bit of practice, especially in the areas where a lighter touch is needed. The tubes in the fourth box show how fine, small lines can indicate shadow areas and create a plant-like stem.

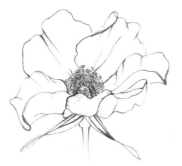

This example of *Rosa rugosa* rendered in line shows how the weight of the line is varied to draw the eye to certain points along the petals, particularly where they twist and turn.

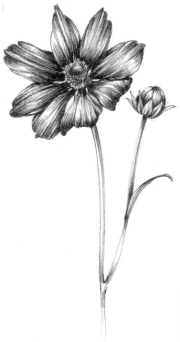

This anemone suggested the use of line, with a heavier application towards the centre creating depth and a lighter application in the middle sections indicating sheen. I used the same technique for the bud. For this and the next studies, I made an initial sketch showing the deepest areas of shadow.

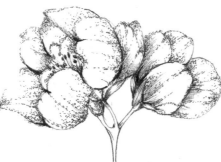

The delicate, sweetly perfumed philadelphus flower needed to be handled lightly; the stippling technique is ideal for this. I applied it more heavily and intensely at the base of the petals and where one petal overlapped another, to create a light shadow.

The iris was handled in a very different way to the previous flower heads. I wanted to create the delicate feel of the petals, so I used my mapping pen to produce an extremely fine line in the shadow areas to emphasize the folds. I turned to a Staedtler 0.05 pen to mark the many veins evident on the outer edges of the petals.

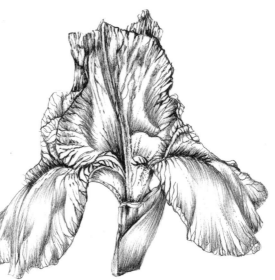

Applying a wash

For applying a wash to your pen-and-ink drawings, you will need a non-permanent ink. First draw your flower and mark where your shadow areas will appear in pencil. Then go over the pencil drawing with your pen strokes, using a fine line.

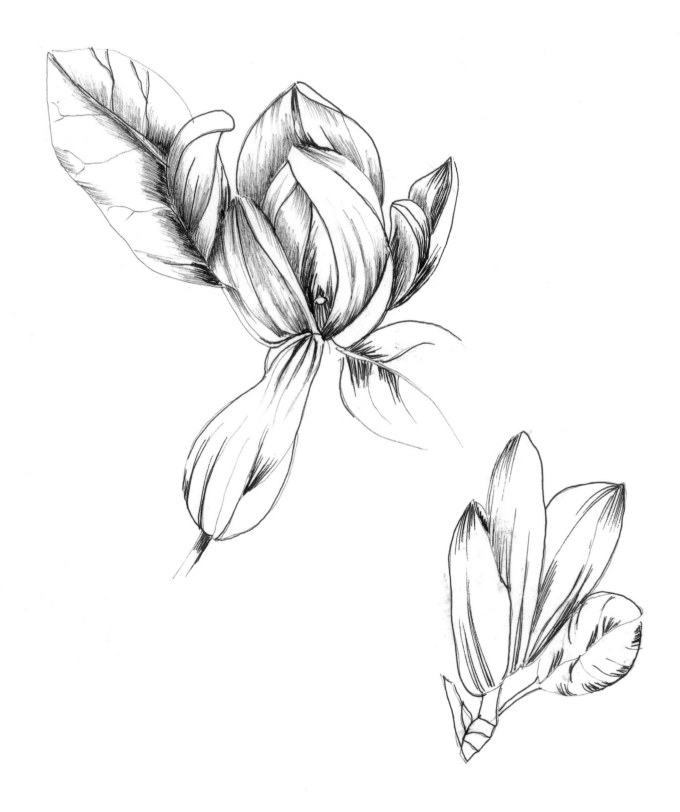

Using a wetted round brush size 2 or 3 (ideally sable), carefully move the ink, creating a wash not dissimilar to that of a watercolour. It is worth practising this technique on a separate piece of paper first. Your brush should only be damp; if it is holding too much water you will lose control of the flow of your ink. It's a good idea to dab your brush on a piece of absorbent paper to remove any excess water first.

Working with light

As a right-handed artist, I usually have my light source coming from the left, hence my shadow areas appear on the far right, with middle tones in the centre and light tones on the far left. A left-handed artist would tend to have their source of light from the opposite direction because if they were to use the same source as a right-handed artist they would be in danger of smudging their work.

Tulip

Here two different examples of light source show how light can alter your flower drawing. Notice how the shadow from the overlapping petals doesn't change very much, unlike the effect of the light on the outside petals which changes considerably. The leaves have been left as a line drawing as we are not concerned with the rendering of leaves in this section.

An initial basic line drawing (far right) showing shadow areas of overlapping petals can be a useful exercise before embarking on your final piece of work.

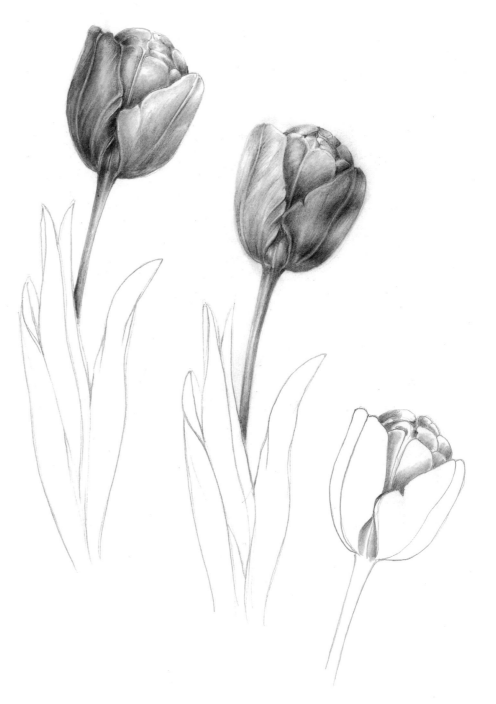

Rudbeckia

For *rudbeckia*, which has a more complex network of petals, a simple line drawing showing the overlapping petals and where the shadows will appear is a help to start with.

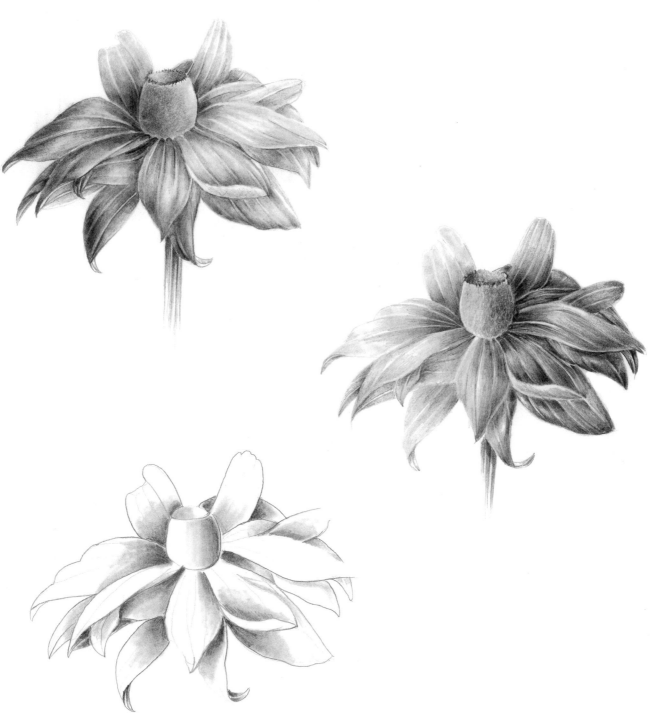

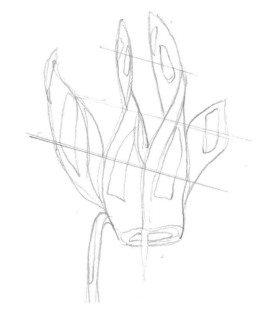

Shine techniques

I find the most effective way of creating shine is to leave the highlighted area either in the lightest of tones, as can be done with a pencil, or to leave the paper completely white without any marks at all, as has to be done when using pen.

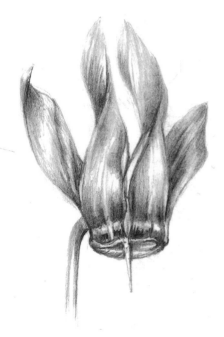

Mark where the shine areas will appear on your initial line drawing. Then, starting from your darkest areas, work the pencil in small ellipses across the page, moving through to the highlighted area where the pencil is hardly touching the paper. Lots of practice is needed to achieve this, but the results will make the time spent well worthwhile.

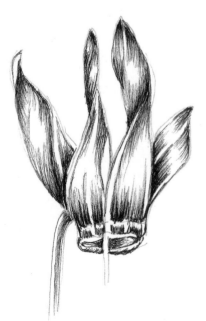

This cyclamen shows the highlighted areas marked out, worked in continuous tone and finally in pen and ink. Notice how the direction of light remains consistent.

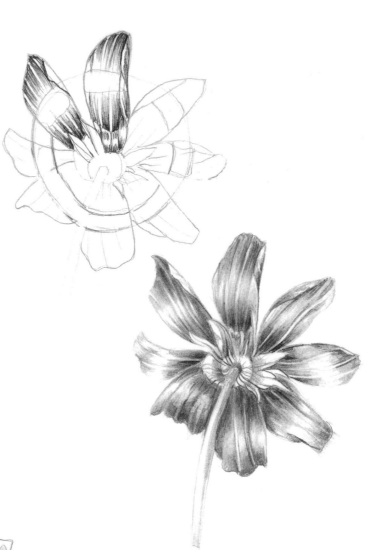

Notice how the light travels around the anemone flower in a circular movement. Two of the petals have been drawn in pen and ink to accentuate this.

Here I drew two sweet-pea flowers on a stem, the first as a line drawing, the second in light pencil tone with the highlighted areas marked out.

I then copied this drawing and worked in pen and ink, using a 0.05 pen for the fine marks on the left petal of the left-hand flower and 0.3 for the stronger lines on the outer edge of the second flower (which would normally be in shadow) and for the centre of the flower.

41

Shine techniques: practice

Marking out a series of squares is a useful exercise for practising your shine technique. In each square here, I took a section from a drawing and worked through them in pencil and pen and ink. These practice exercises take away the pressure of having to do a whole piece of work and the sections worked are specific to the highlighted area.

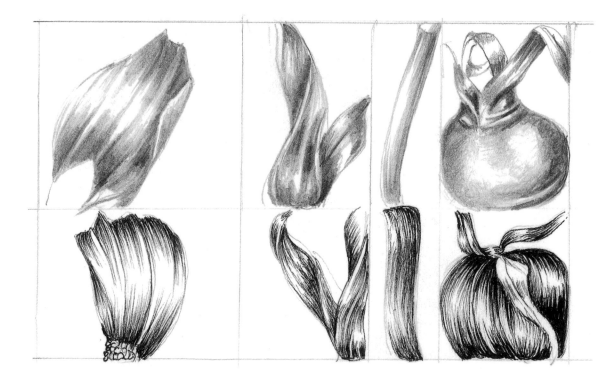

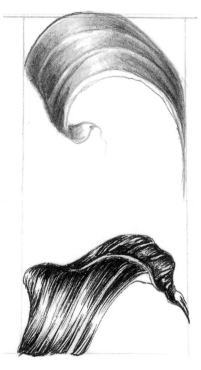

These two *Rosa rugosa* seed heads were done as an example of how to decide which technique is more successful in illustrating shine. I feel that the use of line is far preferable in this case, as the seed head appears glossier than the stippled one.

This tulip was worked as if the light source was coming from the right-hand side. The light is cast on the front bowl of the petal and catches on the tips of the outer petals.

I used a much softer pencil for the calla lily (right) as I wanted to indicate the colour, which was a dark, inky red, and I thought the heaviness of a 4B represented this. Again, I marked out the highlighted areas initially and reverted to a much lighter 2H pencil when I started work on these.

43

Observation through dissection

Dissecting your flower can give you a much greater knowledge and open up a whole new world before your eyes. Observing the often unseen reproductive parts of a flower through a magnifier or microscope will bring a wonderful new dimension to what you can see and what you now know.

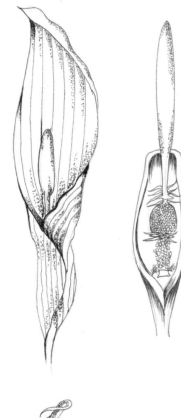

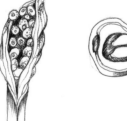

Two examples of dissection are shown here, along with a study of the flower before dissection. In each case I removed the petals with a scalpel to show all the reproductive parts of the flower. Each stamen was carefully taken out with a pair of tweezers and placed on damp kitchen roll to preserve its life while these studies were made. With the aid of a book on botany, each part of a flower can be identified and labelled.

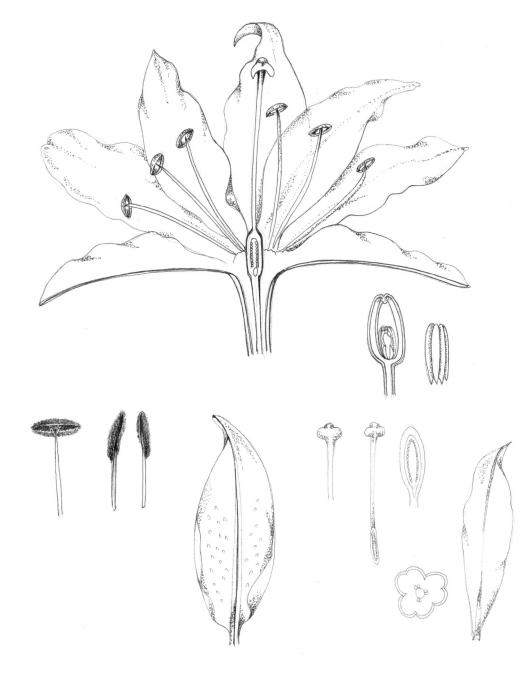

I have kept all parts of my dissected flowers for quite a few years by placing them on some archival mounting board and covering it with acetate to keep it airtight. There is only a slight discolouring of the petals, such as happens when using a flower press.

Botanical drawings such as these should be life-size. Any reduction in size should be to scale, which can be done with the aid of proportional dividers (see page 21).

Chapter 3
Flowers step-by-step

This chapter is dedicated to drawing flower heads, from simple shapes such as the tulip to more complex flower structures, such as the rose and the sunflower. No flower is too difficult to draw – it's simply a matter of breaking down the shapes into manageable bites. In fact some of the simpler shapes such as the amaryllis on page 82 can be more of a challenge than the trickier-looking sunflower with its multi-petalled head (page 80).

Using the method given on pages 26–7 and the simple geometric shapes you've already discovered, this chapter will focus on drawing details such as stamens, roots, bulbs, rhizomes and tendrils. We shall also examine the spiral effect often seen in the centre of flowers, such as *rudbeckia*, and discover more of the effects that come from using pencil or pen and wash.

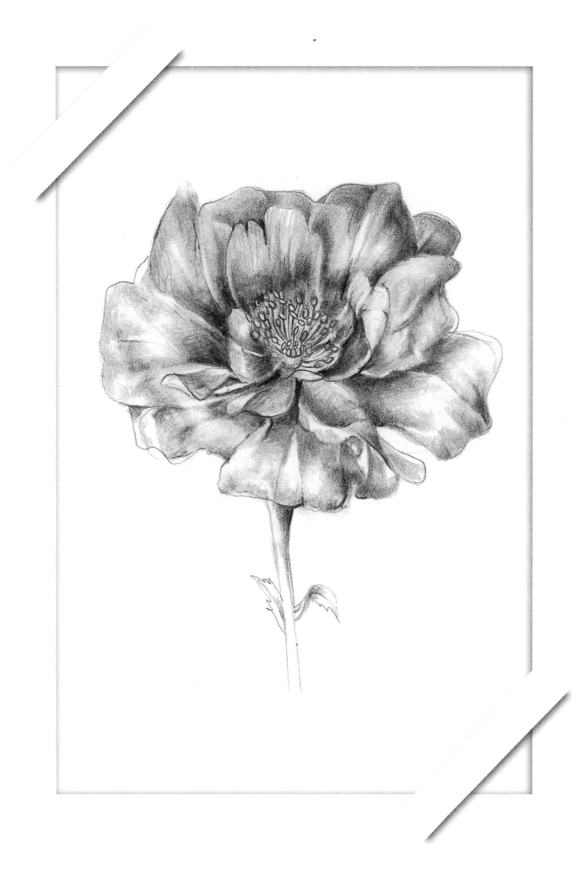

Peony

A peony flower has a simple shape with multiple petals. Once the shape is drawn, you can create form with continuous tone, paying particular attention to where one petal overlaps another. To begin with, I cut a stem and placed it in an orchid holder with a little water. I attached one end of the Wiggly Worm (see page 19) to the orchid holder and the other to my drawing board. This meant I could turn the flower head to the best position for drawing. The buds of the peony are particularly attractive, so I added one – a simple, round shape that is fairly easy to draw.

Taking measurements of the width and height of the peony head, I created a box and drew vertical lines as a guide for the layers of petals. Next I drew the position of the stem and the outer petals.

With a 2H pencil, I lightly worked shadow areas between each petal using small ellipses to create continuous tone, then worked in this way over all the overlapping petals, adding depth of tone at the bottom of the flower.

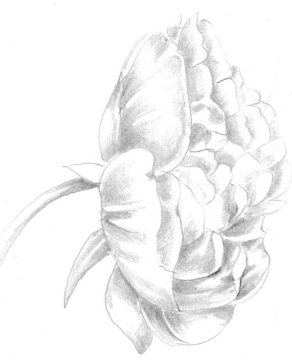

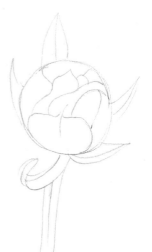

Next I drew the bud, adding detail of the tightly packed petals with simple lines, then following through with tone.

On this occasion, my light source was coming from the right, so the shadow areas were darker on the left, particularly at the bottom. To achieve this effect, I started to darken these parts of the bud and then, using a softer HB pencil, added more depth of tone to the outer encasing petals, alternating with a 2H pencil for the lighter, greyer parts. Care should be taken when working the details of a smaller study. I suggest observing your subject through a magnifying glass to fully understand the detail you will be drawing.

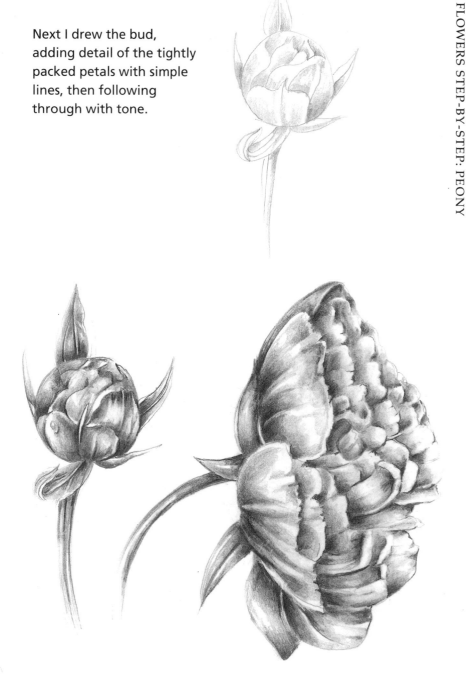

Shadow and light can be confusing for the beginner. It may be helpful at this stage to use your angled board and daylight lamp, positioning the lamp where the main light source in the room is coming from. This will accentuate the shadow areas, making it easier for you to see where they need to be applied. Where the highlights on the petals are brightest, leave your white paper showing through.

Everlasting sweet pea

Unlike the annual sweet pea, the everlasting variety has little or no scent and is sometimes considered a weed, but I love the way it twists through other climbers, holding on with its twining tendrils.

I started by drawing some individual studies of the petals, using my clutch pencil with an HB lead inserted. I started by breaking the flower head down into simple geometric shapes.

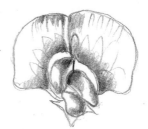

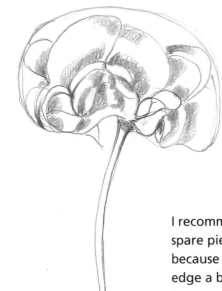

I then added more detail – dips, twists and turns – to these basic shapes until my study resembled a sweet pea.

Next I used my clutch pencil fitted with an HB lead and sharpened with an emery board to give an angled edge. This allowed me to create tone using the flattened edge and fine line with the point.

I recommend working your flattened edge over a spare piece of paper first to make sure it is smooth, because the emery paper can sometimes make the edge a bit grainy. I added small areas of continuous tone, working from the darkest parts and lifting my pencil almost to hover over my paper to create the lightest of tones.

These illustrations show how I drew the tendrils. When you draw them, start with a single looped line and repeat it to make the line double. Where one line crosses another, decide if the loop should go under or over and apply the shadow accordingly. Practise by doing a series of loops – you may find you get hooked on this! Once you've mastered the technique, you will become more adventurous in your addition of tendrils to your final drawing.

I split the seedpod in half to reveal the seeds, then made a study of it. This will be incorporated into the final drawing.

If you have familiarized yourself with all the parts of your flower, the final drawing will be easier. For my study, I cut a stem and placed it in an orchid holder with a little water. I attached one end of my Wiggly Worm holder to the drawing board and the other to the holder. Adjusting the orchid holder, I decided on my best view of the flower and started to draw, taking measurements of the width and height for accuracy.

Thanks to my practice pieces, I was able to achieve a more creative flow when drawing the tendrils. Practice is never wasted – it will always help to give the confidence needed to create a successful drawing.

Tulip in pen and wash

Previously we looked at the tulip as an example of continuous tone and for light direction (see page 38). In this chapter we will look at creating the same image, but with pen and wash.

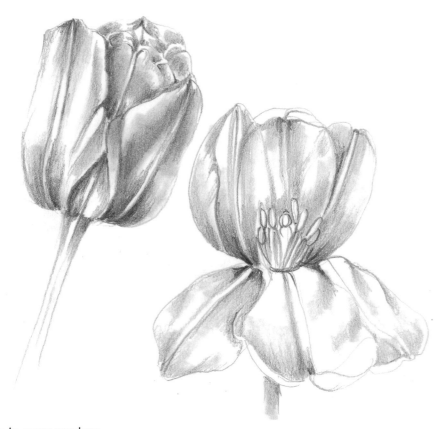

Many of you will have tulips in your gardens, blooming each spring and probably in a wonderful array of colours. They are also available in abundance as cut flowers. These tend to be the smaller, more compact variety, in colours ranging from a pale lilac to a striking striped yellow and red. Other varieties, such as parrot tulips, now come in the deepest shades of purple, and even black. It is worth visiting some flower shows to see the many species available.

If you drew the tulip on page 38 and still have your image on watercolour paper, you can trace this on to tracing paper and, with the aid of a window or lightbox, transfer the image to a new piece of paper. This will be quicker than making a new drawing.

The starting point here is a pencil drawing of the tulip, plus another drawing showing the front petals pulled down and forwards to reveal the stamens (eight in total). I applied shadow loosely to both flower heads using a soft HB pencil.

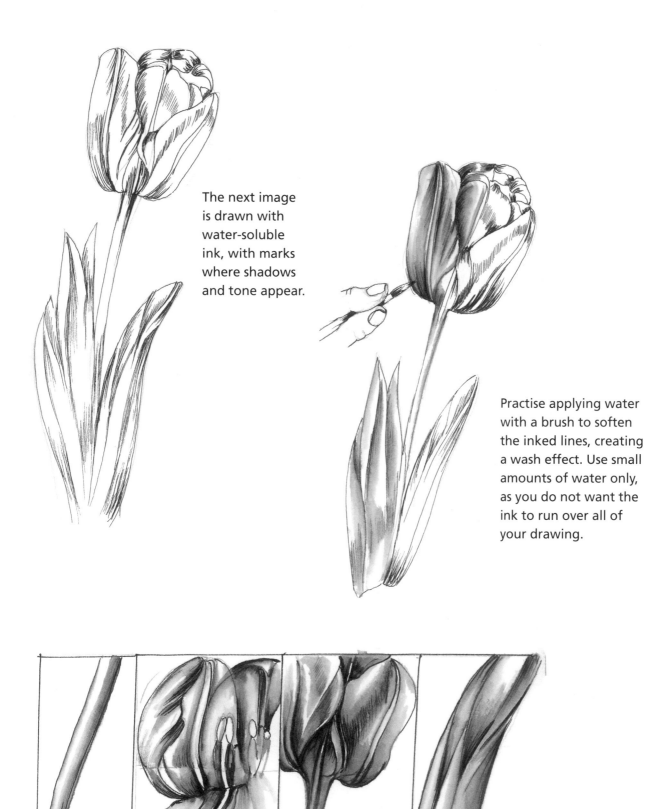

The next image is drawn with water-soluble ink, with marks where shadows and tone appear.

Practise applying water with a brush to soften the inked lines, creating a wash effect. Use small amounts of water only, as you do not want the ink to run over all of your drawing.

It is worth creating smaller images in a box and practising this technique before proceeding to your final drawing. If darker tones are required, reapply the ink and, using your water and brush, soften the inked lines again.

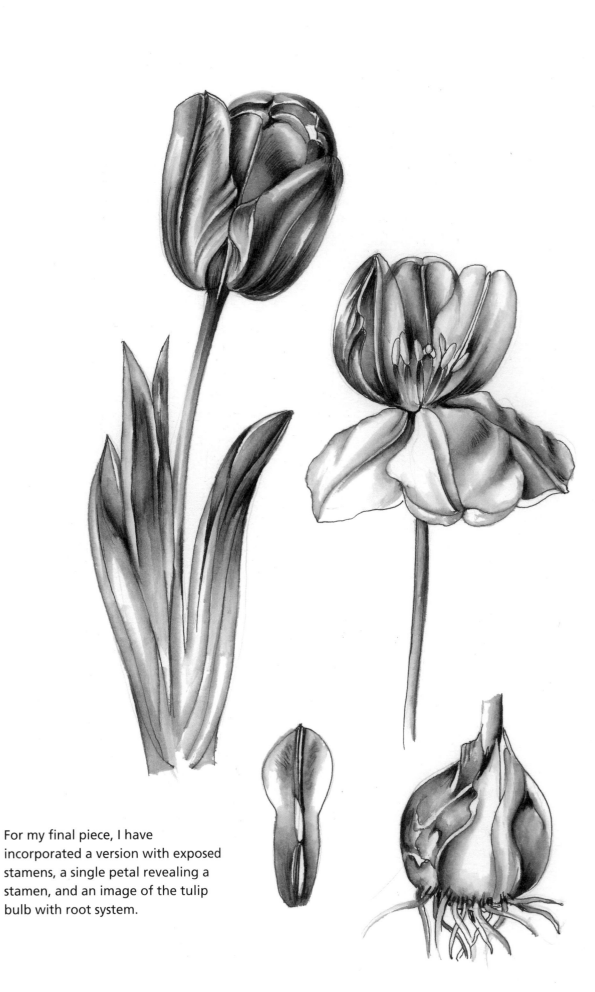

For my final piece, I have incorporated a version with exposed stamens, a single petal revealing a stamen, and an image of the tulip bulb with root system.

Iris

This beautiful, delicate flower rewards its owner with more and more flower heads each year. From a drawing perspective it looks very complex, but as long as you understand the basic shapes within the flower, you will be able to draw it successfully.

I started with a detailed line and tonal drawing of the bud. I knew this bud would eventually emerge as the primary flower head, and that studying it would give me an insight into the formation of the flower and remaining buds.

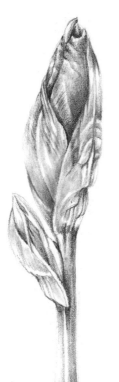

Next I made separate studies of the petals – one fall petal and one standard (the rising petal) – and a line drawing of the flower head.

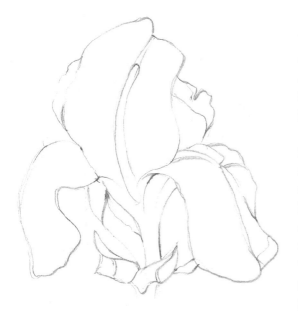

The drawing of the flower head was initially made on tracing paper, as this enabled me to make as many alterations as I needed before transferring it to my Hot Pressed watercolour paper. I introduced part of the leaf into the design.

I darkened the line drawing on my tracing paper using an HB pencil, then, placing it on my lightbox with my watercolour paper over the top, I was able to see my image clearly through the paper. With a 2H pencil, I carefully traced my design on to my paper. You can also use a large well-lit window to the same effect. If you first tape your tracing paper to the window and then place the paper over the top, you will be able to see your image quite clearly.

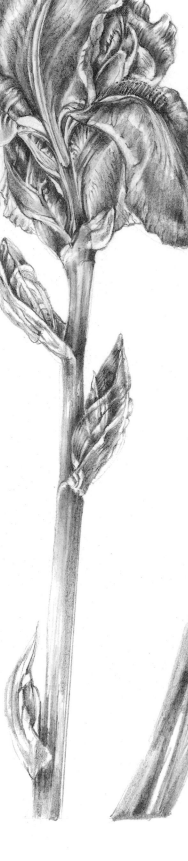

To keep the transparency of the petals, I used a 2H 0.5mm propelling pencil. I angled one side of it and started work on my petals, turning the pencil over to use the sharp edge for the fine network of veins.

Continuing with this approach, I proceeded to put in tone, changing to a sharp HB pencil for the darkest areas. For the shiny buds, I left small white areas to create a glossy effect. I used the 2H pencil lightly for the surrounding spathe – the papery covering that surrounds the bud. Each time I needed to draw in tiny veins, I turned the pencil to use the sharp point. Finally, I worked on the leaf, darkening some areas to give the striped effect typical of this type of iris.

Drawing the tuber or bulb from which your flower has grown can be an interesting addition to your artwork. Here I have drawn the iris rhizome with its root system.

You can see how easy it is to create the roots from a simple line drawing. First draw the roots as single lines, one over another. Then, following your lines, add the other side to each root. Apply shadow where one root crosses over another, continuing until you achieve the required effect.

Rudbeckia laciniata 'Herbstsonne'

There are many different varieties of *Rudbeckia*, and some of them are often mistaken for *Echinacea* which is very similar. Both flowers have intriguing centres, formed in spirals.

This variety of *Rudbeckia* is long-flowering with a height of around 2m (6.5ft). It has large, daisy-like, bright yellow flower heads, with tall, yellowish-green conical centres that become yellowish-brown with age and lose their conical shape.

I have enlarged the centres to give you a better understanding of their structure. The first drawing shows the simple spiral and the second has more detail. Notice how the shapes within your spiral change according to where they are placed – they diminish as they disappear from view at the sides.

The centre of the flower changes with age, becoming more cylindrical, and the small florets burst open before drying into a seed head. Again I have enlarged this to show it more clearly.

I made separate drawings, one with the conical centre (right), one with the cylindrical centre (below). I applied tone to the first, deepening the tones where one petal overlaps another, and keeping light flowing through the centre of each petal (below right).
I drew the leaves, but did not put in any detail, as we are not concerned with leaves in this section.

The second drawing (left) was kept as a line drawing. Here the cone head is dying off.

59

Cyclamen in pen and wash

The delicate flowers of the cyclamen are often seen in wooded areas of the garden, particularly from autumn onwards, and they give a wonderful burst of colour. Grown from tubers, they appear as delightful clumps of pink, magenta and white. For this study, I chose an indoor potted cyclamen in white and used pen and ink to create shadow and form on the flower heads and the beautifully patterned leaves. I used a fine fibre-tip pen containing water-soluble ink. You will also need a round sable watercolour brush, size 2 or 3, for these drawings.

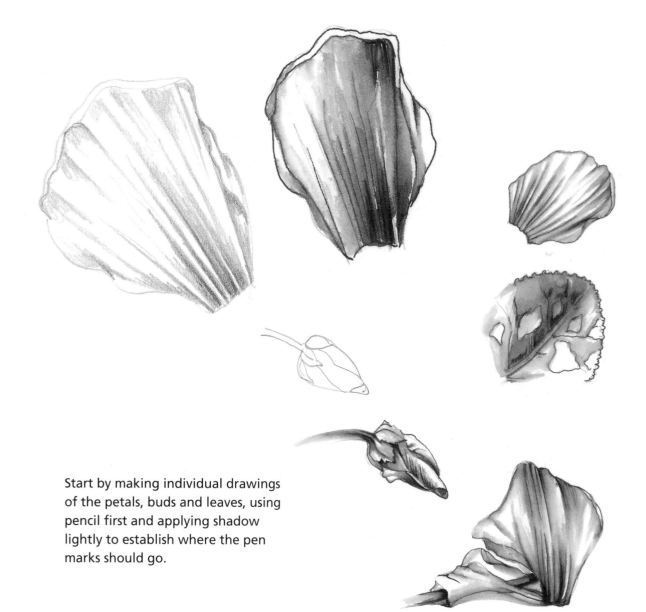

Start by making individual drawings of the petals, buds and leaves, using pencil first and applying shadow lightly to establish where the pen marks should go.

Repeat the drawings, but this time use your pen to apply the marks lightly. Dampen the brush a little and gently wet the pen mark – this will enable you to move the ink across your drawing. Have a piece of kitchen paper or a soft rag by your side for blotting your brush if it's holding too much water. You may need a little bit of practice at this stage before going on to your final piece of work.

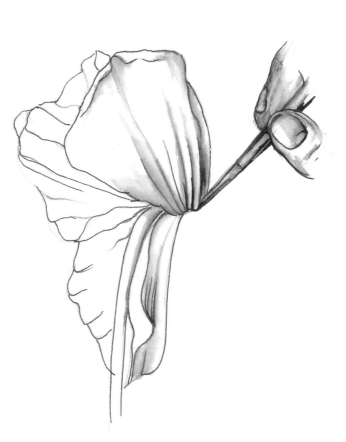

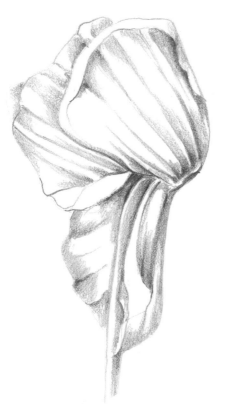

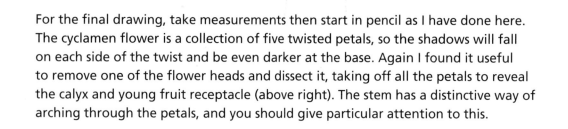

For the final drawing, take measurements then start in pencil as I have done here. The cyclamen flower is a collection of five twisted petals, so the shadows will fall on each side of the twist and be even darker at the base. Again I found it useful to remove one of the flower heads and dissect it, taking off all the petals to reveal the calyx and young fruit receptacle (above right). The stem has a distinctive way of arching through the petals, and you should give particular attention to this.

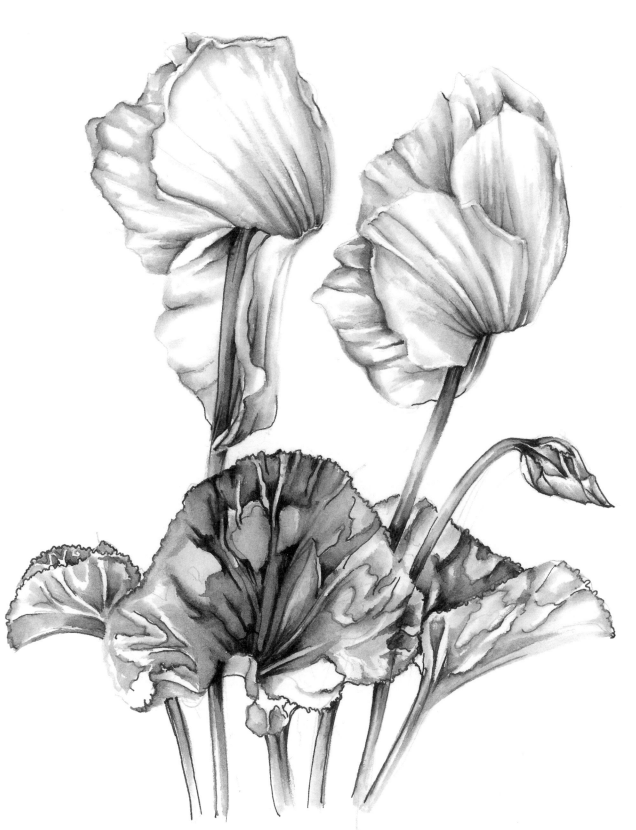

I have loosely drawn the leaves and used pen and wash to show the characteristic patchy pattern. We shall look more closely at this elegant but sturdy leaf in the next chapter.

Japanese anemone

For my first anemone study I have chosen to draw the popular Japanese *Anemone* x *hybrida* 'Robustissima'. A fairly tall plant around 90cm (3ft) in height when mature, it is often found in garden borders. Its pale pink flowers with their deep yellow stamens provide a welcome splash of colour in late summer and early autumn.

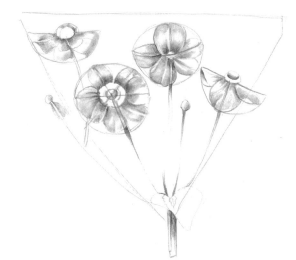

I cut a stem with several flower heads at different stages of development. This also gave me flowers at different angles – I find the most attractive view of the Japanese anemone is from the side, showing the centre and multiple stamens.

Once cut, this flower does not last well, so quick sketches are necessary. As this is a tall flower, I placed it in a long cylindrical vase with a little water and fixed it to one side with masking tape to hold it steady.

In the first drawing (left) I have noted the basic shape of the whole image – a triangle – and placed just the geometric shapes of the flowers in their respective positions along the stem. Using an HB pencil, I roughly shaded where necessary.

With a new piece of Hot Pressed paper and a sharp 2H pencil, I drew the flower heads and left shapes where the stamens would appear.

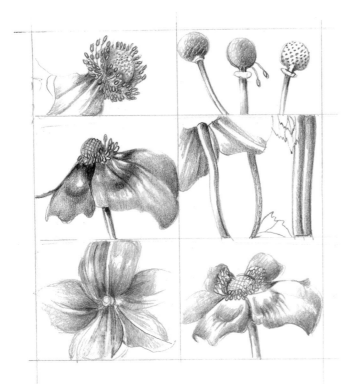

Next I made a series of boxes for my practice pieces and, taking different parts of my flowers, recorded the finer details. I paid particular attention to the stamens since, although they are quite small, I find them a feature of this plant and try to draw them all individually. They are particularly attractive when all the petals have gone and the centre is left with just one or two stamens.

I then added detailing to my line drawing and, using a combination of HB and 2H pencils, proceeded to apply continuous tone. I added deeper tones with my softer HB pencil towards the centre of the flower and used my harder 2H pencil on the lightest areas and to outline the stamens.

Anemone: creating movement in flower heads

The smaller anemones produced en masse for garden centres and flower markets are my favourites, as they come in such glorious colours – blues, mauves, whites, deepest pinks – and with thick, luscious stems.

First I drew a box for measurement purposes for each flower and placed several guidelines to help connect one petal with another.

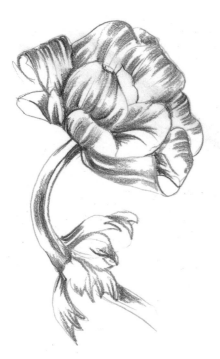

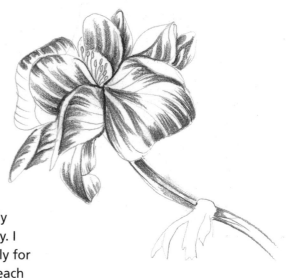

Next I redrew the flower heads and, with a soft 2B pencil, applied tone to show the direction in which each petal was turning. The softness of the pencil allowed me to apply the tone freely and quickly. I varied the tone accordingly for all the dips and curves in each petal, leaving the lightest areas untouched.

The final drawings of the anemones show a much deeper, darker tone. Leaving the light areas untouched helped to give the illusion of petals turning forwards and backwards. Finally, I added the stamens.

Rose

Roses have always been a favourite flower for artists, most famously in the case of the 18th-century French illustrator Pierre-Joseph Redouté, whose three volumes of *Les Roses* contain many cultivars that are now extinct. Of the numerous types of rose available today, I am fortunate to have the lovely, delicately perfumed climber 'Golden Showers', which flowers continuously all summer through to autumn. Starting from a small bud, it develops into a large, blowsy flower, exposing its many delicate stamens.

Sadly, many cut roses on sale today lack fragrance. When you are preparing to draw a rose, I suggest you source a scented one from a garden or florist as a lot of the joy of drawing this magical flower derives from inhaling its wonderful perfume while you do so.

To begin with, I cut a stem and placed it in a vase with a little water. I made a simple tonal drawing of the tightly packed petals and then a further drawing of the opening bud. Making initial studies like these can help you understand the structure of a flower and the way in which its petals interlock.

Taking a measurement of the opening bud, I drew a box and placed the petals within each section. I drew vertical and horizontal lines to aid accuracy and to understand the relationship between the petals.

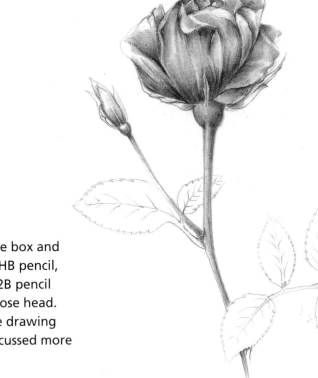

I redrew the rose without the box and made a tonal study with an HB pencil, adding darker tones with a 2B pencil towards the bottom of the rose head. The leaves were left as a line drawing (you will find rose leaves discussed more fully on page 94).

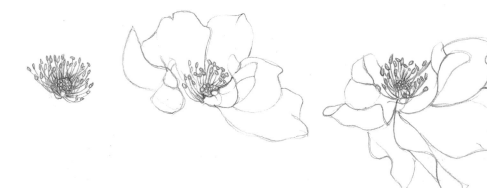

It wasn't long before the rose opened up fully, revealing the many stamens in the centre. I observed the centre with the aid of my magnifying glass and drew a detailed study of the stamens.

Taking a measurement of the width of the top half of the rose, I redrew the central stamens and encased them within the surrounding petals, making sure I created movement in each petal. I applied the same technique to the bottom half of the flower. It is a good idea to practise the curves of the petals as separate drawings before proceeding with your final tonal drawing.

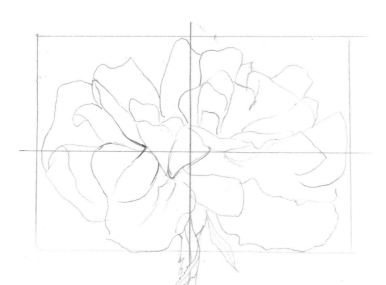

After taking measurements, I broke the rose down into four squares and made a line drawing. Observing the relationship between one petal and another is critical to your drawing. Breaking the process down into manageable pieces makes it easier to understand.

Once you are happy with your line drawing, redraw, and apply the tone. Work from the centre outwards, once again making sure to leave lighter areas on each petal, as illustrated.

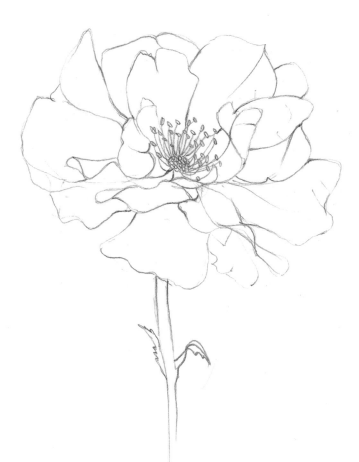

I repositioned the rose to observe it from a different angle. Applying the same technique and initially creating my box for measurement purposes, I proceeded with my tonal drawing. Again, I made separate studies of overlapping petals before proceeding.

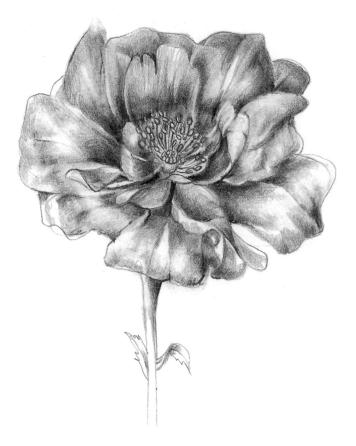

71

Hollyhock

Hollyhocks are a lovely cottage garden plant. They are usually found in sunny borders, planted towards the back because of their height (they can grow to 2.4m (8ft)). When in bloom, they have wonderful large saucer-shaped flowers consisting of five petals. Some people find hollyhocks hard to grow and they can be susceptible to leaf mould, especially in wet weather. They thrive in stony, well-drained soil.

I cut a long stem from the main plant and placed it in a large container with some water. I wasn't sure how long the flower would last once cut, but thankfully it kept its shape and lasted for a good 3–4 days.

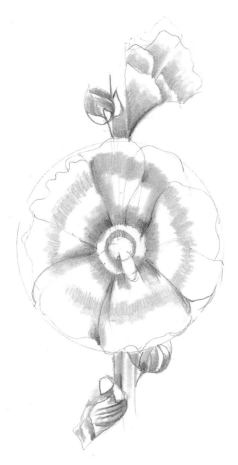

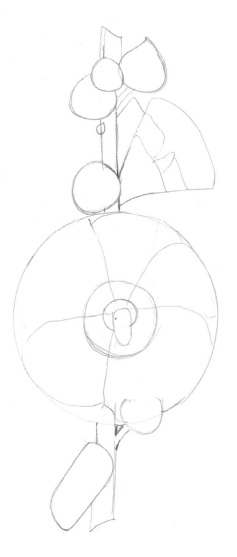

I positioned my cut flower for drawing purposes and, using a sharpened 2B pencil, drew the stem, showing the basic shapes of flower, buds and seedpods. I began to add tone lightly to the shadow areas.

The shape of the flower head is quite simple, but the detail of the veining of the petals is more complex. For this reason, I suggest making separate studies to ensure you know your petal well.

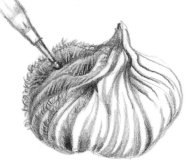

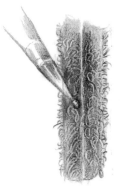

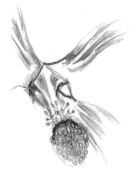

I made a study of a seedpod, finding beauty in the way the furry pod twists at the centre. I also illustrated the hairy stem and emerging bud.

73

Once I was familiar with the different elements of the flower, I redrew my stem with accuracy, adding detail to the flower heads and bud as I had observed in my studies.

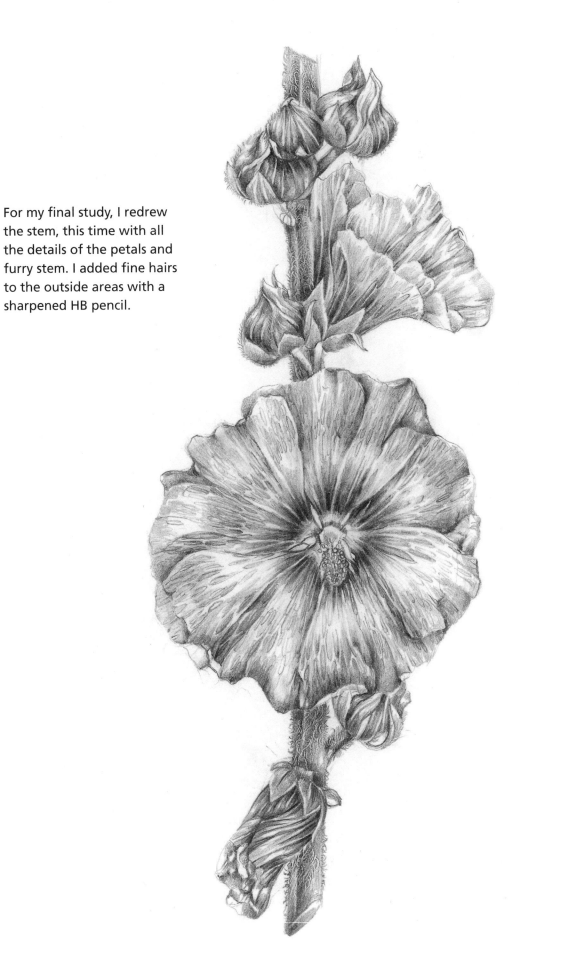

For my final study, I redrew the stem, this time with all the details of the petals and furry stem. I added fine hairs to the outside areas with a sharpened HB pencil.

Hellebore

A favourite winter flower of mine, the hellebore is now available in many colours, shapes and sizes, with single and double flower heads. Colours range from whites to the very darkest reds and even black-greys. I am fortunate to have access to many different varieties at a local hellebore nursery and have, over time, enjoyed drawing and painting them. However, a note of caution – hellebores are extremely poisonous and no part of the plant should be consumed. It is said that *Helleborus niger* (Christmas rose) used to be planted near the house to ward off evil spirits!

Hellebores differ from most other garden plants in that the 'petals' are in fact sepals. Inside is a ring of more solid-looking structures – the nectarines – which are the true petals.

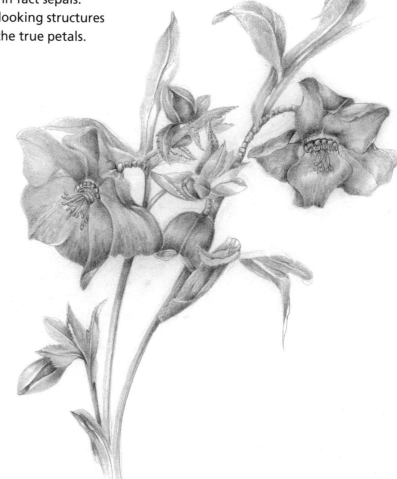

For this piece, I have included more than one flower head, together with buds and a few leaves. I have worked it in continuous tone for simplicity, with no fine detail. As before, your initial drawing can be worked on tracing paper; when you are satisfied with it you can transfer it to Hot Pressed paper.

Using your clutch pencil with an HB lead, concentrate on the arching stems and saucer-shaped flowers. When rendering the part of the stem that travels behind the flower head, draw an invisible line through the flower head to ensure the stem is positioned properly in relation to the flower.

As usual, draw your basic flower shapes, taking note of the angled flower head. Draw your measurement box and note the negative shapes that appear within the box.

Draw a detailed study of the centre, making sure the stamens are distinct. There can sometimes be as many as 150 stamens on one plant, although it's not necessary to draw them all.

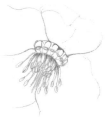

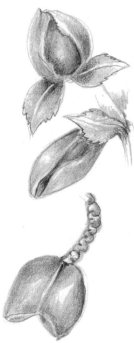

In tight bud, the buds are oval in shape and are usually protected by a small leaf. They develop into an upside-down cup shape before eventually emerging as the full flower. See page 95 for a study of the leaves.

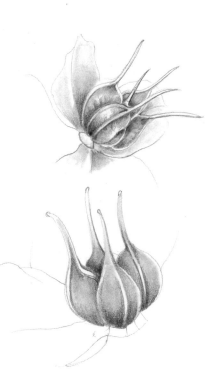

Another very attractive quality of the hellebore is the seedhead. These plump pods eventually dry out, revealing the internal seeds. They are very simple in shape; I suggest drawing a half bowl and placing each oval pod within this space, one overlapping another.

Foxglove

This tall, elegant flower with drooping bells in pink, cream and magenta features in various folklore tales, where it is associated with fairy kingdoms and magical healing powers. Nevertheless, it is poisonous and should be handled with caution. I always advise my students to wash their hands after touching or dissecting any potentially harmful plants.

For drawing purposes, I usually leave plants of this size in a large pot that can be transported to my studio. The flowers last much longer in soil than when cut, and it is preferable to draw a tall plant from a pot on the ground rather than looking up at it from your work surface.

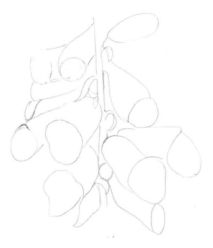

For this drawing, we need to concentrate on the bell-shaped flowers with their lovely markings and fine hairs. First I drew the middle section of the plant, again looking at the basic flower shapes and making a simple line drawing using a 2H pencil and measurements.

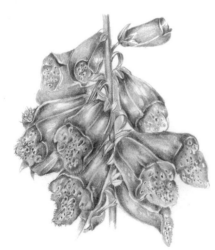

In the next practice drawing I started to work in some tone, leaving the middle section lighter, as I would be using the softer 2B pencil to add the many markings that extend through to the throat of the plant.

Using my clutch pencil, angled with sandpaper, I started to apply the fine hairs that surround the petal (you may need to put in some practice to achieve a natural-looking down). Longer, sparser hairs are sometimes visible in the throat of the flower and these can be added to the final details of your work, again with a very sharp point.

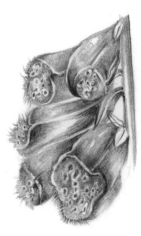

Starting from the top, I took several days to complete the drawing. Each time I stopped for a break, I placed a piece of masking tape at the point I had reached. I started with a line drawing, making sure all measurements were correct. I particularly liked the way the foxglove took on a shape of its own and developed a bend in the stem halfway down. I developed the detailing in the fully opened flowers as I knew they would soon drop away and I wanted to include as many as possible in the final piece. The hairy stems were achieved by working over them with a thin stylus and then applying a soft pencil to reveal the down.

Towards the end I addressed the leaves, which were worked in a fine-edged clutch pencil. This enabled me to include the many veins present. Finally, I went over the whole plant and added fine hairs where necessary.

I think it is always a good idea to put your work to one side when it is finished and then to come back to it. It can be difficult to be objective when you have concentrated on it for so long, so reassessing it at a later stage is a worthwhile exercise.

Sunflower

The botanical name for the sunflower is *Helianthus*, deriving from the Greek *helios* (meaning 'sun') and *anthos* ('flower'). It acquired this name because the flowers follow the sun by day, always turning their faces towards its rays.

The large round head of the sunflower is a complex overlapping of simple petals. The disc florets inside the circular head create a pattern of interconnecting spirals; there are typically 34 spirals in one direction and 55 in the other. The leaves and stem are rough and hairy.

Get the feel of your sunflower by making a loose sketch. By all means, take measurements at first and put semi-circular guidelines in place, but there is no need to be too precise about your drawing. Enjoy the way your pencil depicts the petals with movement. As long as the basic shape is correct, there is no need to count the number of petals you put in. With a soft HB pencil, loosely put in your shadow areas – you will know by now that they tend to fall behind each petal. A much softer pencil will be needed for the back of the flower.

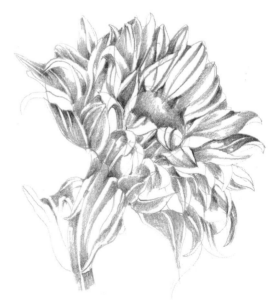

The sepals and stem

To create the hairy sepals and stem, using your stylus or chosen implement for indenting your paper, make marks on your paper as though you are drawing hairs. Then, using continuous tonal movements over your drawing with a soft 4B pencil, you will see the hairy sepals appear as illustrated. Use the same method with the stem, extending the hairs from the edge with a 2H pencil.

Use the stylus to create a hairy texture

Soft pencil is drawn over stylus marking to reveal hairs

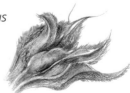

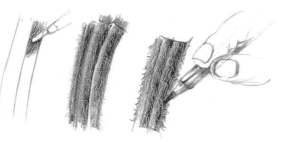

Stylus is used on stem to create hairs

External hairs are applied with fine pencil

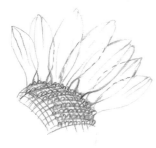

The final drawing

When you come to draw your final piece, you will have learnt a lot already with your practice pieces and this will probably have given you confidence. Starting with the first petal, work around the circular centre, drawing one petal overlapping another. Sometimes I place a small piece of masking tape on the petal I have just worked as it is easy to become confused about where you are. Try to retain the petals' movement that you had in your practice piece.

You want the petals to appear much lighter in tone than the back of the sunflower. By using a harder pencil such as a 5H you can avoid applying too much dark tone. Handle the hairy back of the flower and stem in much the same way as the practice piece, using a soft 4B pencil. Complete your drawing by adding the fine hairs extending from the stem and any other parts of the back of the flower with a 2H pointed pencil. Finally, stand back and look at your flower again to see if you need to make any adjustments.

Amaryllis

This majestic flower, grown from a bulb, is not one of the easiest subjects to draw. There are many different varieties of amaryllis, but the most commonly found have large red or white flower heads. Should you wish to grow one yourself, expect it to flower about six weeks from the time you plant the bulb.

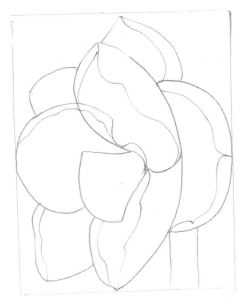

To make this drawing, I first cut the stem of the flower and placed it in a long glass with a small amount of water. I attached the stem to the glass with a small amount of masking tape to hold it still.

For your own drawing, take the width and height measurements of the flower head and make a box. Spend plenty of time observing your flower, assessing the basic shapes within it. Your initial sketch should be made up of these basic shapes – it is more an interpretation than an exact likeness at this stage.

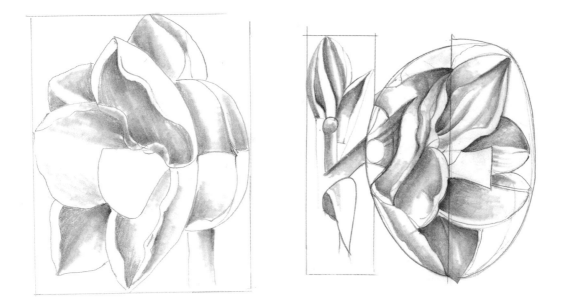

Once you begin to work more detail into the petals, your flower will start to take shape. Using a 6B pencil, introduce shadow, usually where one petal overlaps another. If necessary, use your daylight lamp, positioning it to shine either on the left or right of the plant, as this will help you understand where your shadow areas should appear. Then, taking your tortillon, smudge the pencil. Smudge into areas where shadow is present, as this will start to give you the form of the flower head. Note where the highlight areas are, and lift any overworked pencil with your softened putty rubber.

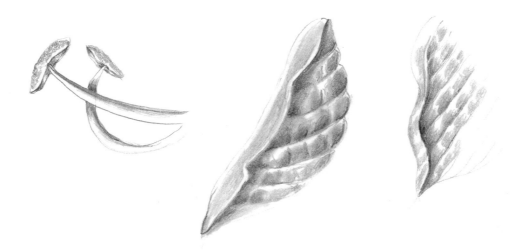

Before you start on your final drawing, I suggest some practice pieces, as shown. The detail in the petals can be represented by small areas of continuous tone, worked lightly with an HB pencil and darkened where necessary. Examine the stamens under a magnifying glass so that you fully understand their form.

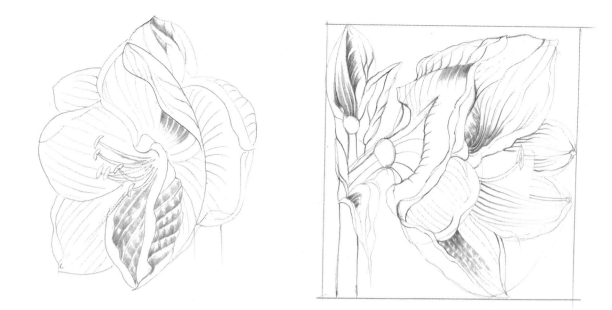

You should now have a better understanding of your flower head and be ready to move on to your final drawings. Start with your line drawing. Take measurements and refer back to your initial drawings showing the basic shapes, as these will give you a good indication of how to proceed. First place six stamens and anthers at the centre so that they continue to stand out in the final drawing. Mark the veins in line and then with continuous tone as shown in the illustration. Continue with more tonal work, referring back to your initial shaded drawings and fresh flower head for reference when necessary.

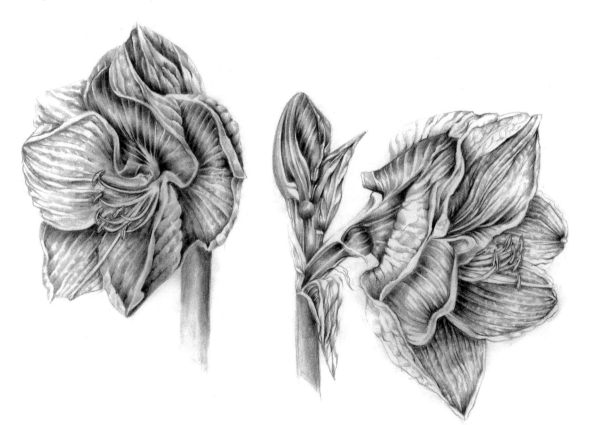

When all your groundwork has been finished, reassess your drawing. It may be that you will need to use a much softer pencil, say a 4B, for more depth of tone in the darkest areas, or you may need to use your putty rubber to lift off where the light hits the petals.

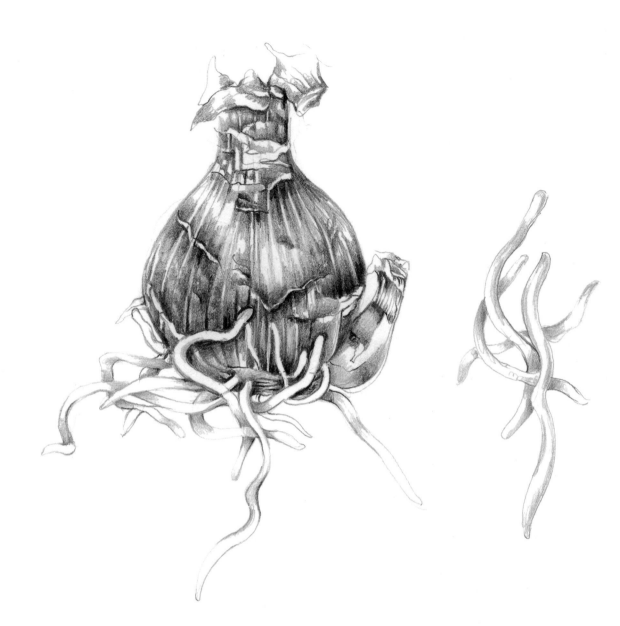

The amaryllis bulb

This illustration shows the bulb and fleshy root system from which the flower grows. The bulbs are papery in texture and quite beautiful in their own right. There are many different areas of tone to tackle, with darker tonal areas towards the bottom section where the roots emerge.

At the end of flowering each year, cut the flower stem, wrap the bulb in newspaper and place in a cool place until the following year. Replanted and placed in a semi-lit warm position, the bulb will sprout again. Sometimes the flower even sprouts twice in the same year.

Chapter 4

Leaves

Leaves are an important part of your plant. They provide a key to its identification, so they should never be underestimated or misinterpreted in your drawing. While they can be a challenge for the artist, you'll find that observation and practice will bring success and act as a valuable educational tool. As John Ruskin wrote, 'If you can paint one leaf, you can paint the World.'

The study of leaves is a vast and fascinating subject. In this chapter we'll consider different types of leaf formation, the tracery of veins on a given leaf, and how leaves grow from a stem. When we look at a leaf we often do not see the intricate detail that is so important. The underside of a leaf often gives more information than the upper surface about the position of veins – for this reason, I sometimes suggest doing a leaf rubbing (see page 89).

A thorough understanding of botany helps with leaf studies, but this is more than the beginner may want or need. For those requiring greater knowledge on the subject, I recommend *The Cambridge Illustrated Glossary of Botanical Terms* by Michael Hickey and Clive King. As well as being a nicely illustrated book, it is useful for learning the terminology employed to describe the parts of a plant.

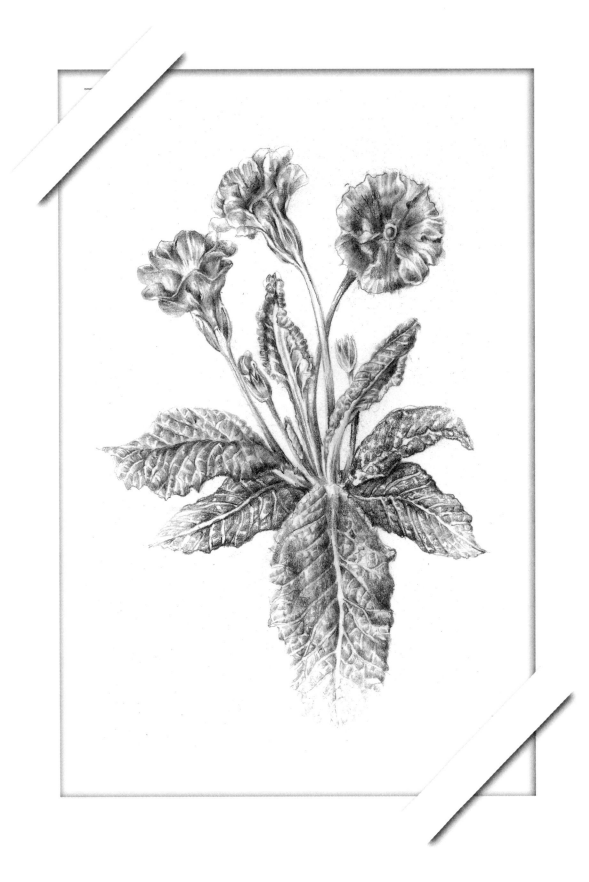

Leaf structure

Here we look at the importance of the position of the central vein, or midrib, and the way the leaves turn backwards and forwards. To practise, draw a simple leaf shape, positioning the central midrib and the leaf veins.

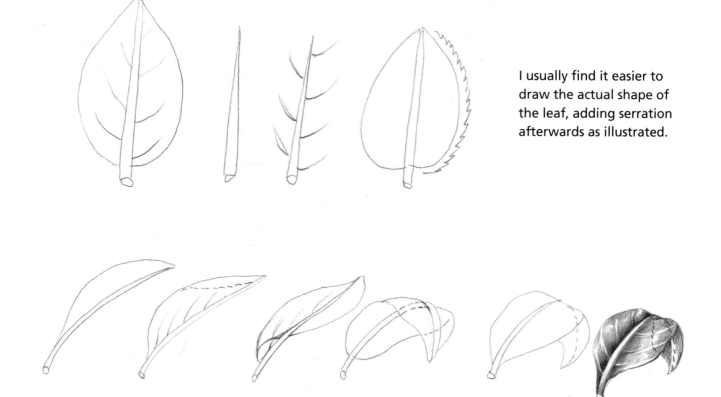

I usually find it easier to draw the actual shape of the leaf, adding serration afterwards as illustrated.

Draw the leaf turning, making sure the midrib connects each time the leaf turns. Forwards and backwards turning leaves are illustrated here.

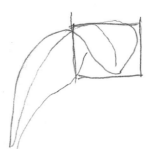

Here I show how to draw and understand a foreshortened leaf, by measuring the leaf turn, drawing a box and fitting the turned leaf inside the box.

Leaf rubbing

Make a rubbing to study the reverse of the leaf – this can help with understanding how the veins connect with one another.

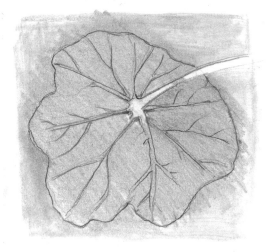

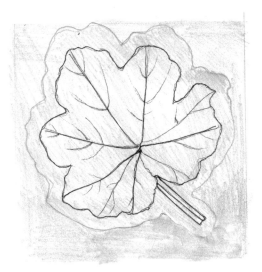

Take a leaf and turn it over to reveal the underside. Place a piece of tracing paper over it and gently rub over the leaf with a soft 2B pencil. All the veins should show through, as illustrated here.

Cut around your leaf rubbing, then place another piece of tracing paper over it and redraw, this time using a pen with waterproof ink. Mark the outline and all the veins. Cut around your leaf tracing, leaving a decent margin around the edge.

Next, take some floristry wire or fine bendable garden wire and cut two pieces the length and width of the leaf. Attach them with small pieces of clear tape to the reverse side of the cut-out tracing paper. Your leaf drawing is now flexible. When the traced drawing is bent over you will be able to see where all the other veins appear. This will give you a greater understanding of their formation.

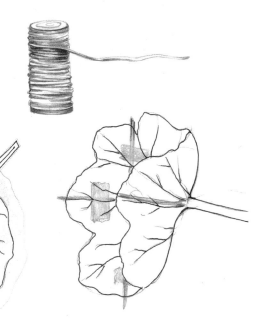

Leaf joints

While it's important to learn about the shape of a leaf, it's also important to know about the leaf joint – how the leaf attaches to the stem. This varies from one genus of plant to another.

Virginia creeper

Here is a line drawing of a lovely climber whose true beauty is seen in the autumn when the leaves turn a reddish-orange colour. The virginia creeper has palmate leaves: five individual lobes formed from a stalk attached to the main stem. Tendrils also grow from the main stem; these attach the creeper to the structure it grows against.

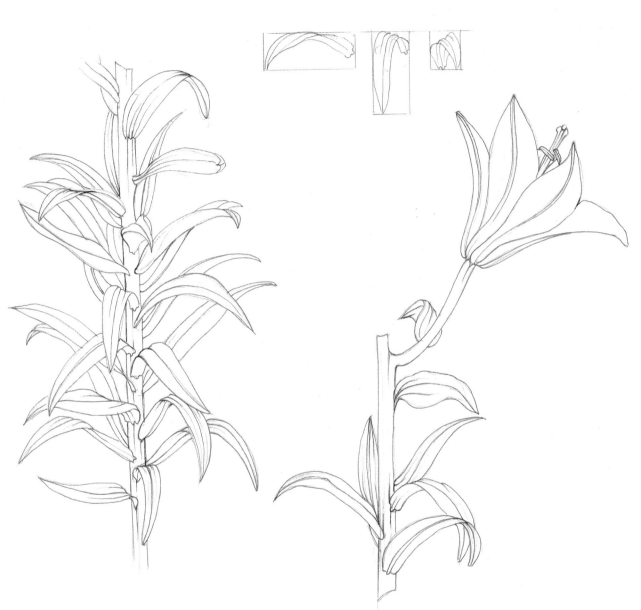

Tiger lily

Here I paid more attention to the stem and leaves than the flower. The leaves grow around the stem, showing forwards- and backwards-turning leaves, and some that are foreshortened. I drew some practice pieces using boxes for the foreshortened leaves. The final stem and leaves were drawn first in pencil, using a 2H pencil to create a light line. Once I felt they were accurate I reworked them in pen and ink to accentuate the clean lines of the leaf attachments to the stem.

Dewdrops

A pleasing addition to a drawing or painting, dewdrops on leaves can easily be made to look realistic. Start with a simple oval shape and apply a light tone with a 2H pencil. Work around your highlight, or twist your putty rubber into a small point and lift off the pencil, taking you back to the white of the paper. Apply shadow underneath the lighter side of the dewdrops and darker tone on the opposite side.

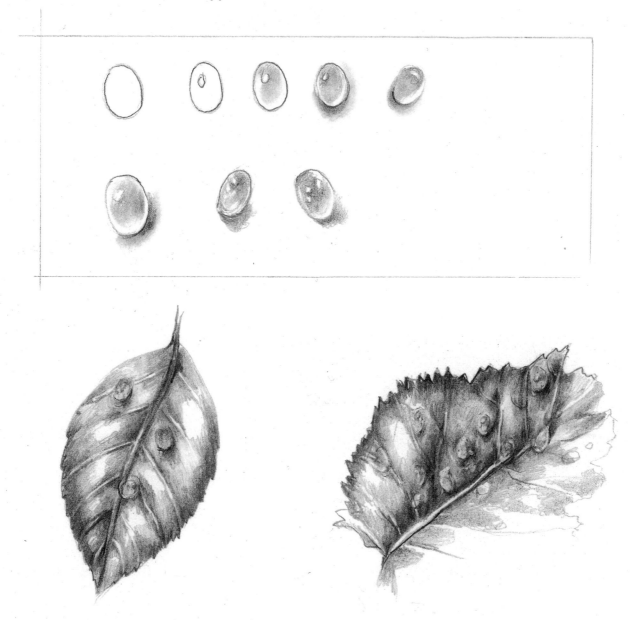

Once mastered, drawing dewdrops can be quite addictive – but beware of overdoing them or they will become a cliché in your work. The examples above show a rose leaf with some dewdrops (left) and an *Alchemillis mollis* leaf (right). The latter is a beautiful sage green leaf well known for retaining dewdrops after a downpour.

Leaf studies: from line to tone

Here we look at two different types of leaf – the anemone, with its flat, simple markings and the more complex hydrangea with its many veins. The leaves can be worked in different ways to achieve the required effect.

Anemone leaf
I drew the anemone leaf and positioned the veins. I drew the main veins in a heavier line and the smaller tertiary veins more lightly.

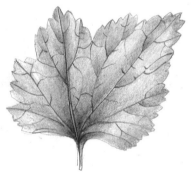

Using the flat side of an angled clutch pencil with a 2H lead, I applied continuous tone lightly all over the leaf. Re-evaluating what I had done, I applied more continuous tone to areas where it was needed, using heavier pressure towards the centre bottom and edges of the leaf.

Hydrangea leaf
After drawing the leaf shape I carefully marked in all the main veins, using a double line. I then drew the smaller veins in position, using a clutch pencil with an HB lead and a sharp fine point created with an emery board.

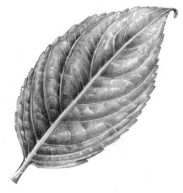

Next I applied areas of continuous tone between the smaller veins, working from dark tone through to light. The whole leaf was worked in this way. I used heavier pressure on the main and centre veins until the required level of density was achieved. Changing to a harder 2H pencil with an angled edge, I worked over the whole of the leaf with only the lightest of pressure to bring all the detail together.

Ginkgo biloba

Also known as the maidenhair tree, *Ginkgo biloba* grows to more than 40m (130ft). It can live for over a thousand years and is one of the oldest species of tree on the planet, considered a living fossil.

Its leaf is of great beauty, simple yet stunning. After drawing the shape, I applied a light continuous tone with a 2H angled pencil. I drew in the veins with a fine HB propelling pencil lead, following the movement of the leaf. When I had finished I gently picked out areas with a putty rubber.

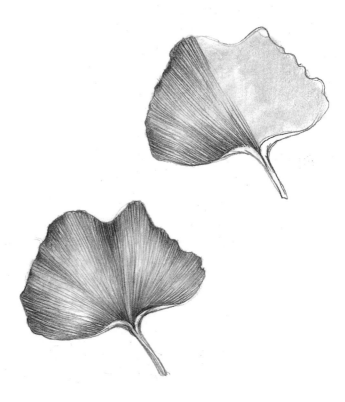

Rose leaf

Illustrated below is a rose leaf attached to a stem. Dark and glossy, rose leaves have very fine veins and serrated edges. As this leaf is newly formed, it has small, almost insignificant veining.

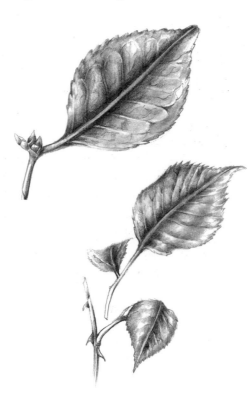

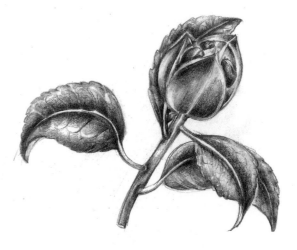

Camellia leaf

This detailed study of a camellia leaf shows veins and tone to illustrate depth of colour and shine.

Fern

Ferns reproduce via spores and have neither seeds nor flowers. They are a lovely addition to a shady spot in the garden, quite fascinating for the many different varieties available. This illustration was first drawn in pencil and then gone over with a fine Rotring pen.

Hellebore

Hellebore leaves and flowers grow separately. This illustration shows the newly formed bud with a backdrop of the hellebore leaf. Hellebore leaves can be unusual in that the central vein on some leaves is offset. They have a fine network of veins which can be seen by holding the leaf up to the light. It is not necessary to illustrate all the veins, as the naked eye does not see the detail that can be observed with a magnifying lens.

Cyclamen leaf

I chose two views for the cyclamen leaf and drew the patterned areas of dark and light.
I worked the darkest parts first of all with a sharpened 4B pencil, then used a tortillon to
drag the dark pencil gently into the lighter areas, creating the soft edge typical of the
markings on this leaf. Finally I worked the edge, again with a very sharp 4B pencil.
I worked the side view of the leaf in the same way.

Hollyhock leaf

The veining of the hollyhock leaf is complex. As with the hydrangea leaf, I marked out the main veins first and then the network of tiny veins, shown in the bottom section of the main drawing. Then I applied continuous tone with a sharpened fine-point 2H pencil, working from dark through to light in each section.

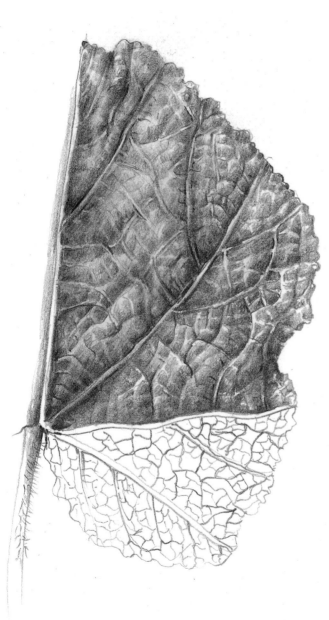

These smaller practice pieces (above and below) show a similar hollyhock leaf with partial detail and tonal application.

Observing the leaf once again, I saw where darker areas of line should be applied. With an HB pencil I darkened around the main veins, then to finish I worked over the whole leaf with my 2H pencil to pull each section together, applying more areas of darkened tone where necessary.

Hairy leaves

The leaves of some plants have hairs which act as a barrier to protect the leaf from moisture loss. Take care to examine the length and direction of the hairs. They can be fun to draw – you can make the marks by indenting the page with the help of your stylus, then working lightly over the marked leaf with a soft pencil.

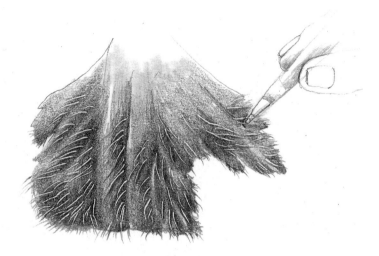

Poppy leaf

On a poppy leaf, the hairs are usually sparse and quite thin and long. I used a fine stylus to mark them out, observing their direction, then worked over the area with a 2B pencil, leaving some parts lighter. Using a sharp pencil, I gave each hair a darker shadow on one side, which helped define the hair follicle. I applied hairs to the outside of the leaf with the same pencil, using a light flicking movement to create a natural-looking down.

Stachys byzantina leaf

The common name for this plant is lamb's ears, on account of its shape, lovely silvery-grey colour and long, downy hairs.

After drawing the leaf shape, I marked the area with a fine stylus, indenting the paper with long strokes and altering the direction in swirls at the bottom of the leaf. I think this gives it an almost damp look. Using a soft 2B pencil, I worked over the whole area, again adding darker shadow behind each hair with a sharp pencil. Then, with a soft putty rubber, I lifted out areas to create lighter patches of pencil.

Sunflower stem and leaf

This study shows the sunflower leaf in detail and its relation to the hairy stem. As in the drawing of the hydrangea leaf, I created detail in line then applied continuous tone, suggesting movement. I used the stylus to indent the hairs on the stem and worked over the marks with a 2B pencil to create a soft, downy look.

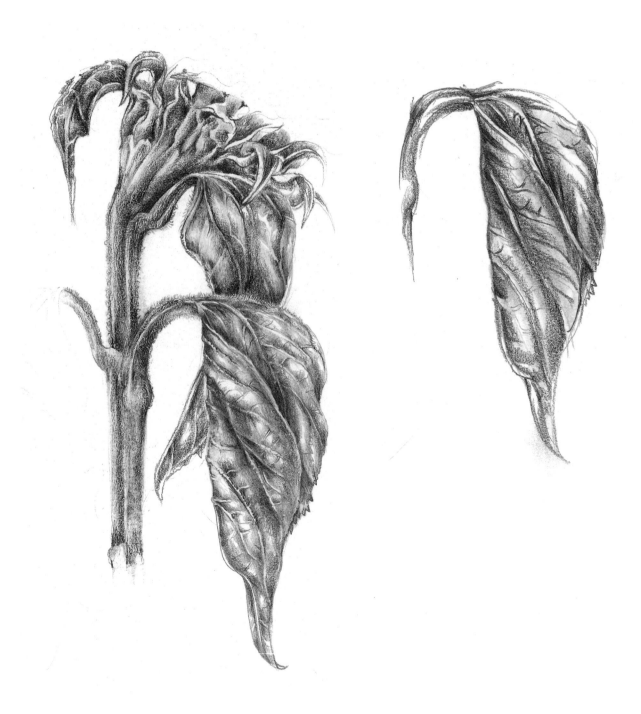

Autumn leaves and shadows

Applying cast shadow underneath the study of a leaf makes it appear more realistic and lifts it off the surface of the paper. I have chosen a few autumn leaves here as they tend to take on interesting shapes and textures. The structure of the dying leaf is fascinating, as it curls inwards and becomes skeletonized. Collect a few interesting leaves in the autumn and practise drawing them. If shadow is not present in daylight, use your daylight lamp and direct the light towards your leaf so you can see where to place your shadow.

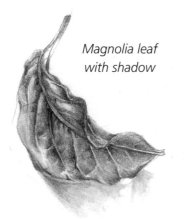

Magnolia leaf with shadow

Magnolia leaf turned inwards with shadow

I recommend applying shadow with a pencil, even if your final drawing is to be in pen and ink. Working over your pencil shadow with a tortillon gives you the freedom to remove any excess graphite. All too often I have seen shadow applied too heavily, as a definite shape, and it tends to dominate the artwork. Less is more in this case and just a suggestion of shadow is far more effective. The darkest shadow tones should be applied directly underneath the object, then you can smudge the pencil out in the direction of the shadow using your paper stump.

Skeletonized leaf in pencil

Skeletonized leaf in pen and wash

Collect freshly fallen autumn leaves and preserve them by pressing them on to acid-free paper and covering with clear film, taped down to exclude any air. You may wish to label them before you add the film. I have kept leaves in an excellent condition in this way for several years and they will probably last for many more years to come. Alternatively, collect leaves that have dried; they are excellent for practising different tones.

Another two leaves, one in pencil and one in pen and wash, are both skeletonized. The lacework effect is a challenge, but worthwhile from an observational point of view. I used a finely pointed clutch pencil with an HB lead for the skeletonized effect, and an angled lead for the remainder of the leaf.

For the skeletonized leaf in pen and wash, I used a fine pen with water-soluble ink and a damp brush to move the ink to achieve a washed effect. The skeletonized lacework was drawn with a fine waterproof 0.05 pen.

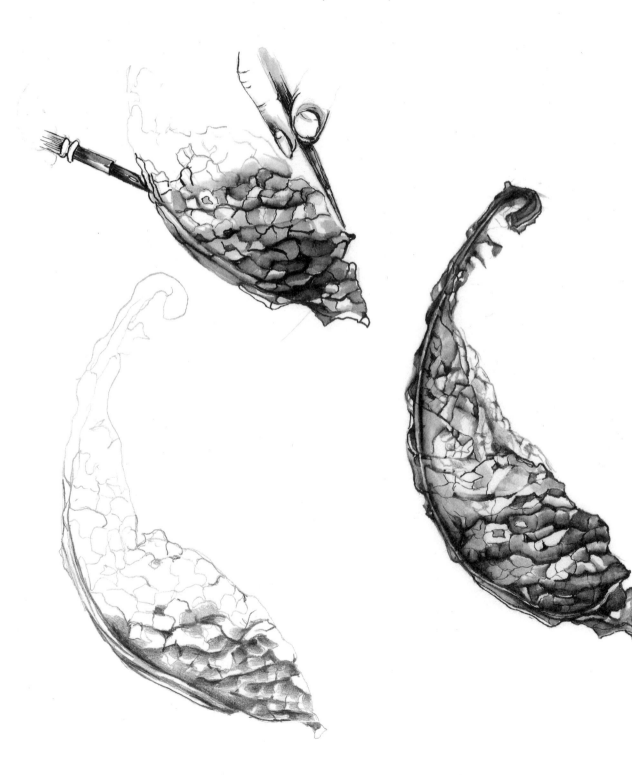

Glossy leaves, berries and seedpods

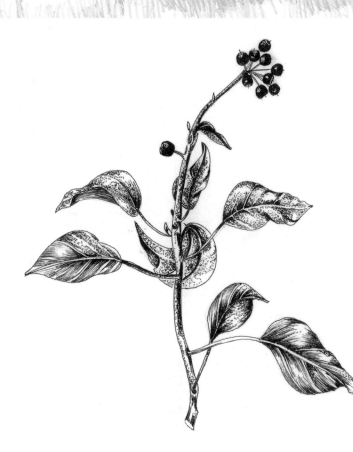

Ivy berries

In this drawing I have used pen techniques of line and stipple to indicate the tonal values of the leaves. By contrast, I applied ink more heavily to the glossy berries to make them stand out.

Holly leaf

Holly leaves are dark green and glossy; sometimes spiky, sometimes smooth. The smoother leaves tend to come from older trees or from higher up on the tree. Holly trees can grow up to 15m (49ft) and live for 300 years.

A stem with berries is shown here, with areas of the paper left white to accentuate the shine on the spiky leaves. The leaves are dark and glossy with strong highlights, with a fine paler line visible round the edge. I put a soft 2B lead into my clutch pencil and sharpened it with my emery paper, then worked it carefully from the darkest edge towards the highlight. Rather than working from dark tones through to light in continuous tone, I used my pencil to create a stippled effect with a series of fine dots into the highlighted areas, making the dots less dense the further they went into the highlight.

Mahonia leaf

Mahonia is an evergreen shrub grown for its attractive foliage. The leaf is similar to that of the holly, but much larger and more elongated. Mahonia has bright-yellow fragrant flowers in the winter, which ripen to form blue-black edible fruits. I used the same technique as for the holly leaf, but this time worked in continuous tone into the highlighted areas. I added some of the fine dark veins using a freshly sharpened pencil with a fine point.

Camellia leaf and seedpods

The thick, dark green, glossy leaves of the camellia have serrated edges and are arranged alternately along the stem. The flowers, which bloom in late winter or early spring, resemble a multi-petalled rose, especially when seen in the pale pink, white and rose colours. This illustration is of a camellia leaf and seedpod, which is unusually large. It was found on a plant in Italy; the pods had broken open to reveal the lovely black seeds within.

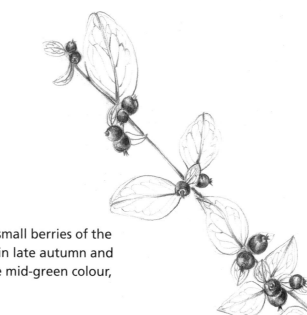

Honeysuckle

I am particularly attracted to the small berries of the honeysuckle plant, which appear in late autumn and winter. They start off an attractive mid-green colour, then turn a glorious purple-black.

Leaf studies

Although these studies show flowers and a seed head rather than just leaves, the texture and size of the leaves draw the viewer's eye. The primrose (below) has a complicated leaf structure with lots of undulations. These can be approached in the same way as the hydrangea leaf on page 93 and the hollyhock leaf on page 97, by marking out the vein structure and using continuous tone to describe the areas of dark through to light.

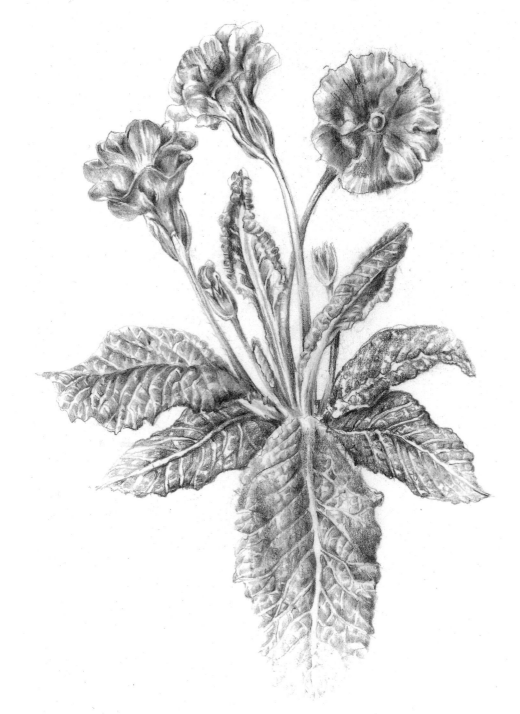

As we have seen, dried leaves can become skeletonized as they decompose. This illustration shows a poppy plant during this process, with the seedhead as the focus of the drawing.

Chapter 5
Composition

Works of art are defined not only by how they are drawn but also by the way in which the artist displays them on paper. The composition you choose for depicting your flowers can transform a simple study into something much more dynamic and interesting. Always remember to think through the positioning of your subject on the page before you start work. Over time, this process will come naturally to you and you may even decide on a particular format that works best for your drawing style.

As well as composition, in this chapter we also look at the effect of negative and positive space. Sometimes you may want to display just one part of a large plant – we explore how cropping can be used to best effect and how you can enhance certain characteristics of a plant by making them a focal point. Today the preference is for a more contemporary style of flower drawing, and we look at ways this can be achieved.

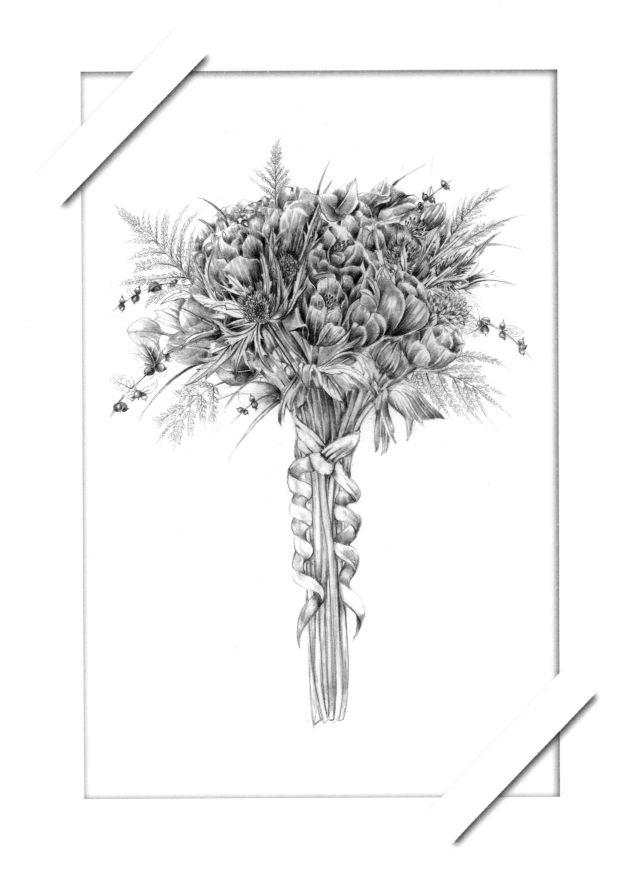

Creating a composition

It can be challenging to create a composition with more than one flower, but this process is made easier by using individual drawings and putting them together. First, draw your subject on tracing paper with a fine pencil, then go over it with a permanent ink pen. Cut round the tracing paper. Below is an example of three flowers (anemones) separately drawn on tracing paper and cut out.

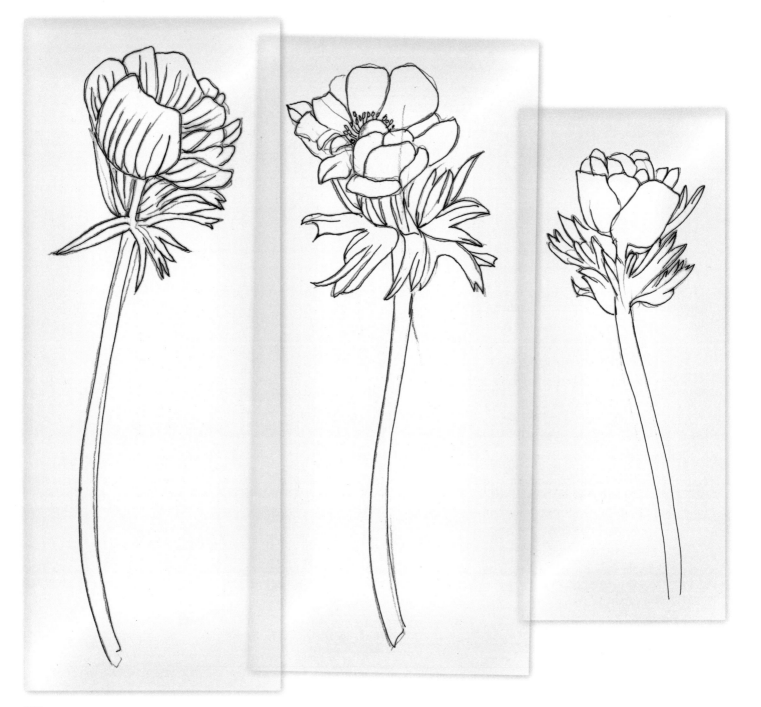

On a piece of white paper, place your flowers in an arrangement you find satisfying. Of course, with the drawings on separate pieces of paper, you can change this as many times as you like – angling, turning or shifting the flowers higher or lower. Once you have decided on your final composition, tape the pieces of tracing paper to your white paper. You will now have three separate drawings, one on top of the other.

Place a fresh piece of tracing paper over your composition and redraw it. Remember to leave out the lines where stems and flowers cross behind each other, as these should not be seen in your final design.

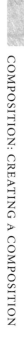

For simplicity, I have included just one type of flower in this example, but you could use the different flowers, leaves and seed heads you have previously drawn on tracing paper to create an interesting and varied composition.

Two ways with composition

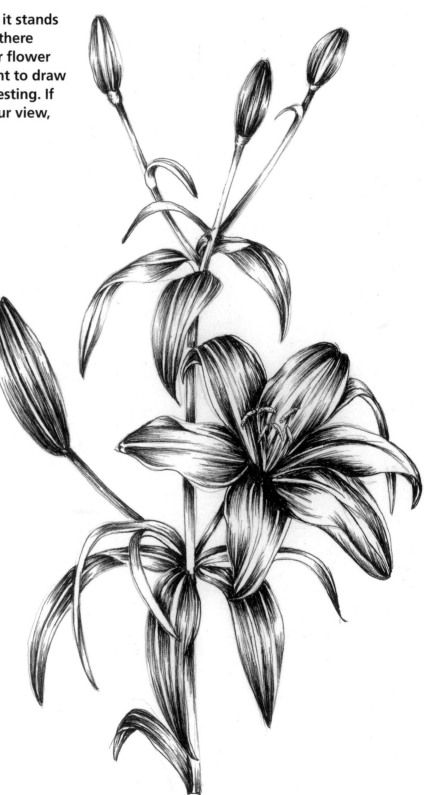

Instead of simply drawing a flower as it stands before you, always consider whether there might be a better view of it. Turn your flower round until you find an angle you want to draw from, which the viewer will find interesting. If an awkward leaf or petal obscures your view, push it to one side or remove it.

This page shows the lily 'Enchantment', drawn with all the elements of the growing plant – flower head, buds, stems and leaves. The full flower is centrally placed to draw the eye in, while the large bud on the left also draws the eye to this side of the composition.

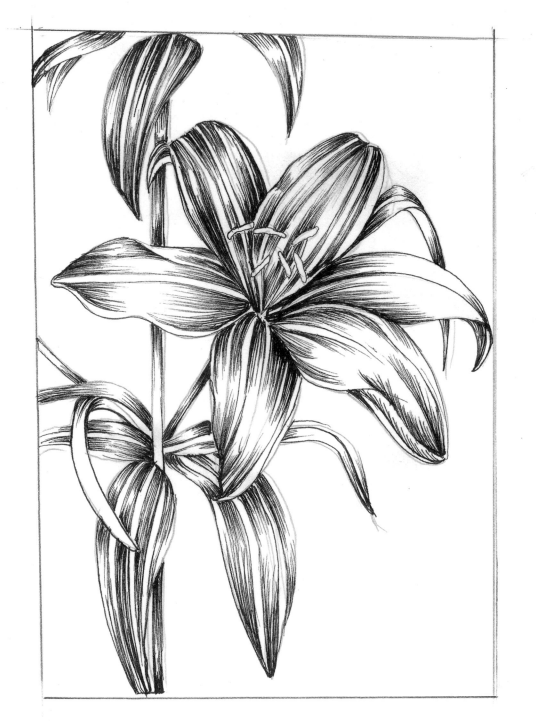

For an interesting and altogether different view, you can crop a section of your flower and place it to take up the whole space. If you have some spare mountboard, cut out two L-shaped pieces and lay them over your image, moving them around to see what different crops look like. Don't be afraid to experiment, as this will help you to find compositional ideas for future studies.

With the lily above, I have used the full flower as my main focal point. For interest, I retained some leaves entering the top of the image boundary, prompting the viewer to wonder what lies beyond.

Experimenting with composition

The seed head of the artichoke plant is a popular subject for artists, particularly when it bursts open to reveal the many fine, plumose hairs in the centre. As a suggestion for a composition, I have drawn a box round one section of the main illustration, cropping in on a single seed head and on part of another.

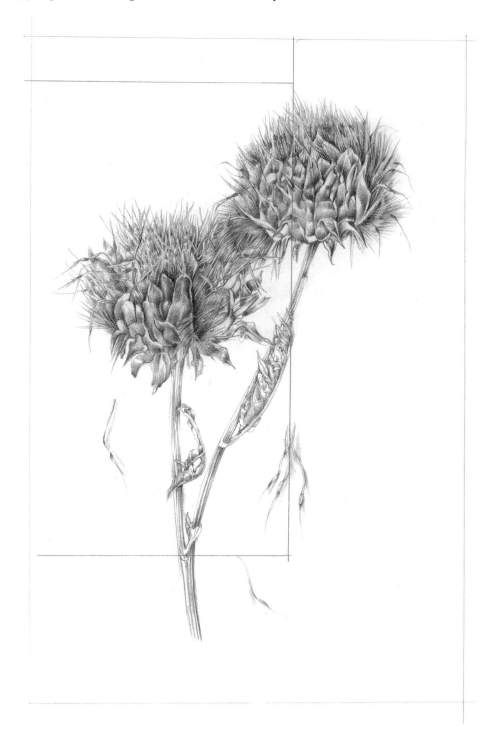

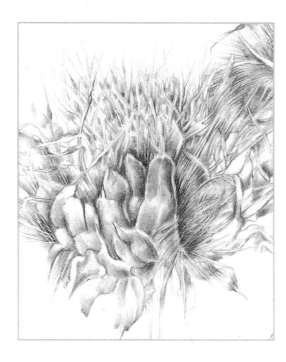

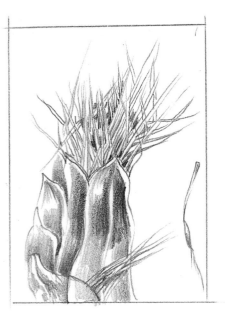

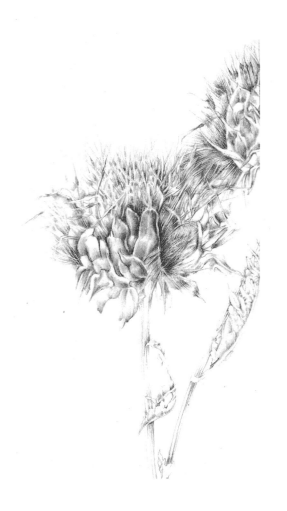

Using two L-shaped mountboards, I experimented by sectioning off parts of the composition to see how drawing parts of the whole subject might be preferable.

Aerial perspective

Using aerial perspective creates the illusion of depth in your composition. Where necessary, the flowers closest to the viewer are generally rendered bolder and larger than those behind. This may not be as important in flower drawing as in landscape drawing, where depth of field is more easily understood and established, but the same principles apply.

By studying the stem of this rose, you can see that some of the rose hips are at the front and some are behind. To create depth, I have drawn the hips at the rear slightly smaller and paler, while drawing the hips at the front larger and with greater definition. The tones of the rose leaves behind the stem are also pale compared with the leaves at the bottom right, which are much bolder.

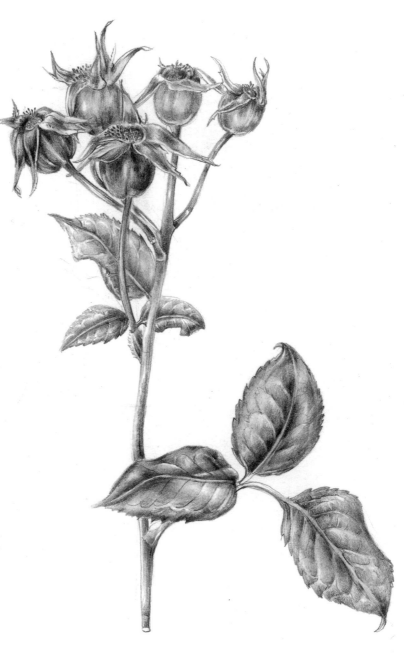

Negative space

The negative spaces within a picture are the areas with no image in them (the positive space being the image). This means that there are three elements in a composition: the negative space, the positive space and the surround (the perimeter, within which the image resides). You need to give thought to how you place your image on the paper, especially if you feel the negative space should play an important part.

Here I have drawn an example of *Iris foetidissima* seed heads. Initially I drew my boundary, then roughly put in the seed heads where I wanted the finished drawing to appear on the paper.

As this plant tends to arch and fall when growing in the garden, I decided to place my leaves on the left of the composition and bring the stems of the seedheads into play. I wanted to engage the eye so that it travels easily from left to right, where the image finishes with a few dropped seeds from the heads. The leaves and flowers emerge from the left, taking up the bottom portion of the paper and leaving almost exactly the same amount of blank space opposite – the negative space. I also placed the leaves by giving thought to the negative spaces next to them, especially where the seed heads arch above the arched bottom leaf. I feel this nicely mirrors the negative space at the top of the drawing.

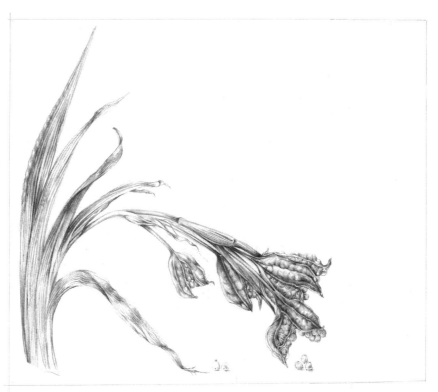

Hosta: two approaches

Hostas are grown mainly for their wonderful leaves, but they have the added attraction of tall, sometimes perfumed flowers. They are an attractive garden plant and make a wonderful display in pots, increasing in size each year. Unfortunately, they are a magnet for slugs and it is unusual to have a hosta plant without a few ragged, eaten leaves; but the artist can choose to leave these out, of course.

Variegated hosta

I drew the first composition, of a variegated hosta, with pen and ink. I used pencil for the initial planning, making guidelines to indicate where the pen-and-ink marks would go. I chose a 0.1 permanent ink pen to convey the movement and striped effect of the many overlapping leaves. I also added the long-stemmed flowers, though I feel the main composition concerns itself with the variegated leaves.

Hosta 'Halcyon'

The leaf below was taken from a beautiful blue hosta variety, 'Halcyon'. This plant produces long stems of fragrant flowers up to 40cm (16in) in height. In contrast to the variegated hosta drawing, I designed this composition more as a botanical study. The leaf is shown in full detail, with the flowers and buds placed to the rear.

I drew the hosta in pencil, paying particular attention to the leaf veining and the convergence towards the centre, where it becomes finer and thinner as the leaves merge at the stem. It is a simple but effective composition.

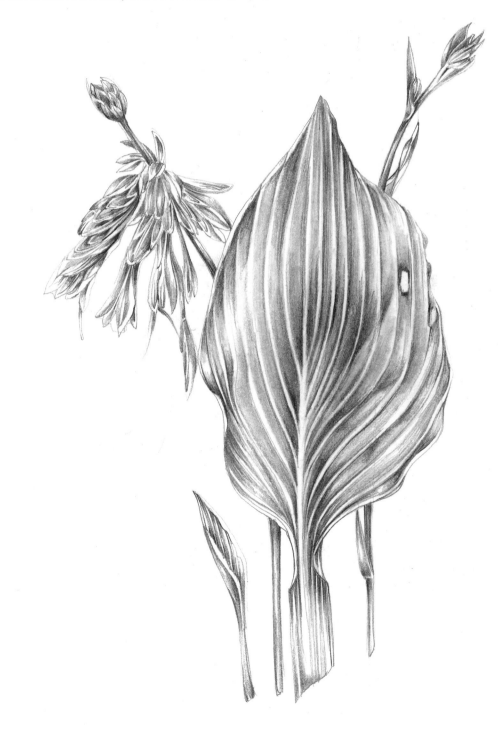

Contemporary compositions

Instead of taking the traditional approach, you may wish to display your flower in a contemporary composition. Here are two examples of this: Chinese lanterns (*Physalis alkekengi*) and a single stem of *Clematis vitalba*.

Chinese lanterns

These plants are usually grown for their attractive papery 'lanterns' and to add colour to the garden in autumn. They have bright orange fruit, visible when the flower has become skeletonized. As this process is rather beautiful, I wanted to make a drawing that focuses on the dried lanterns.

For the wider view (below right) I chose a more contemporary design, showing a few lanterns within a rectangular boundary.

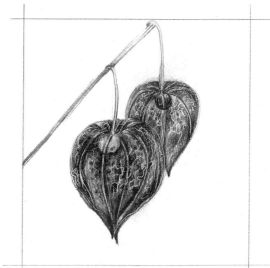

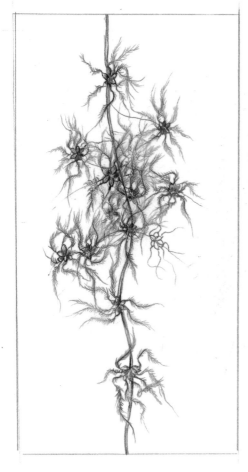

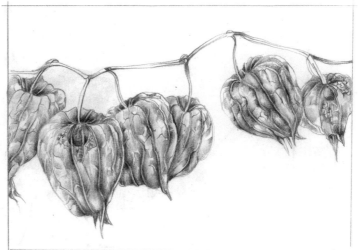

Clematis vitalba

Often it is sufficient just to show a single stem set alone on a page (see left). As a compositional piece, the simplicity of this can be very attractive. The lovely silky seed heads of this clematis are seen in abundance in hedgerows in winter. It is commonly called 'old man's beard', since *en masse* the seed heads resemble just that.

The French name for *Clematis vitalba* is 'herbe aux gueux' – the beggar's herb. Beggars were said to use the sap to irritate the skin and give themselves sores to try to elicit sympathy from passersby.

Botanical studies

There are 20 or so species of snowdrop. The one illustrated here is *Galanthus nivalis*. It grows to 7–15cm (3–6in) tall and blooms between late winter and mid-spring, with the white flowers appearing in clumps.

I have drawn this snowdrop almost as a botanical study, with all aspects of the flower head taken into consideration. The six tepals, or segments, are illustrated, with three larger outer ones and three smaller inner ones. The latter have distinctive V-shaped, yellow-green markings. It looks a simple shape, but drawing the snowdrop accurately can be difficult. I recommend a magnifying lens and a 2H pencil with a fine-pointed lead.

In recent times, botanical studies have given way to looser artistic impressions. This study of the snowdrop falls between the two disciplines. By this I mean that I have not taken any artistic liberties with my drawing, nor have I rendered it as a botanical study with dissected parts showing. Dissected parts are not limited to scientific illustrations – they are often added to illustrations for interest. This is where proportional dividers are invaluable, since the parts dissected are generally so small that it's necessary to show them at an increased size. It is also important to show the magnification size next to the image.

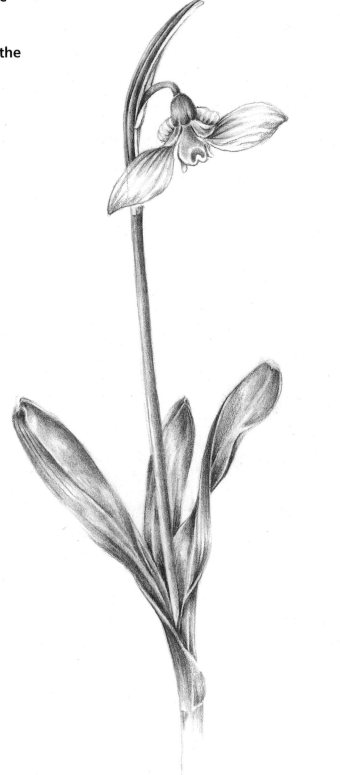

Large plant composition

When drawing large plants, it is usually more successful compositionally to crop the outer parts rather than trying to fit everything on to the page. Cropping emphasizes the magnitude of the subject. Alternatively, you can simply omit parts of the plant and go for simplicity instead.

Commonly known as the bat plant, *Tacca chantrieri* is a very unusual species native to the Asian rainforest. The flowers (more correctly, bracts or modified leaves) resemble a bat in flight with flowing whiskers. The flowers can extend to over 60cm (2ft) in length.

The plant I used as my subject was so large that it proved difficult to draw, so I decided to cut the flowers as they bloomed, which enabled me to view them at eye level. I drew the flowers over three consecutive days.

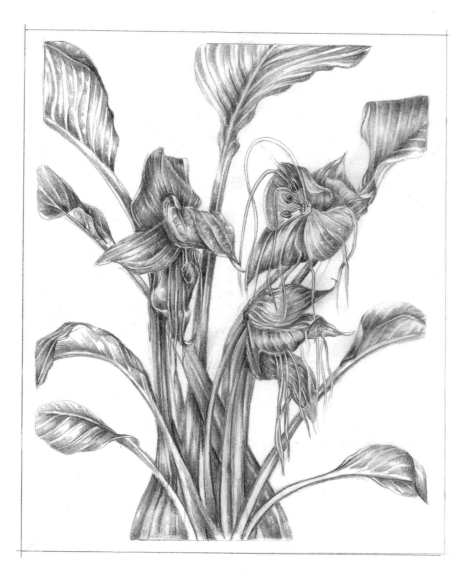

I made several drawings before deciding how I would like the plant to appear on the page. The leaves were enormous, so I chose to crop all of them at the perimeter. I placed the mount 4cm (2.5in) away from the cropped leaf edge to show that the crop had been done deliberately as part of the composition. Then I placed the flowers as they had grown.

With a plant that won't last long when cut, it's sometimes worth taking photographs as an aid. However, it's not advisable to draw completely from photographs as they are a poor substitute for the real thing.

Slipper orchid

I found this slipper orchid when visiting a specialist orchid nursery; the owner kindly cut two flowers for me to draw. These unusual flowers have a slipper-shaped lip which, in nature, helps pollination. The clumps of hairs on the petals resemble a short, dark moustache.

As with the bat plant, the leaves of this orchid can be quite large, and incorporating them into an illustration would involve some cropping within the image boundaries. For this composition I chose to draw just the two hanging flowers. I liked the idea of the simplicity of these orchid heads without the additional complication of leaves. I drew the front flower with much darker tones than the second flower, as I wanted the latter to recede, adding depth to the image.

Flower arrangement

This illustration shows an arrangement of flowers, berries and leaves such as might be seen in a bouquet. The arrangement is simple, with anemones, fern, honeysuckle berries, small-headed geraniums and, for some architectural contrast with the soft petals, a lovely steely-blue *eryngium*. This went well with the blue-grey of the eucalyptus leaves, which gave a lovely fresh perfume and lasted long after the fresh flowers had died.

Before embarking on an arrangement such as this it's a good idea to draw the individual flowers separately to familiarize yourself with them. Make only rough sketches; the flowers will change as they either open or start to wilt, so you need to draw the arrangement as quickly as possible.

Where one flower is behind another, take care to apply shadow, leaving the petal in front lighter in tone. I left the leaves of the *eryngium* lighter to make them stand out from the other flowers. Finally, I tied a ribbon around the arrangement and left it to hang on each side of the stems, adding darker tone where the ribbon turned. You may need to practise darker and lighter tones to suggest the twist of the ribbon before adding it to the arrangement.

Lisa's wedding bouquet

Sometimes I am asked to design wedding invitations featuring drawings of the flowers from the bride's bouquet. But I was delighted to be asked by a friend to draw her daughter's wedding bouquet in pencil as a gift to commemorate her special day.

Roses are perfect for a wedding bouquet, especially when they have a soft, delicate perfume. This bouquet was made up entirely of these flowers, with creamy Vendela roses used for the outer blooms and soft pink roses at the centre. The bouquet was encased with skeletonized leaves in ivory, giving it an ethereal quality. These leaves were specially made for the purpose and are quite different from the naturally skeletonized leaves on page 100.

Entwined within the bouquet are silvered leaves and strands of crystals. Wanting to keep the delicacy of the flower heads, I worked each outer rose in a fine 2H angled pencil, giving more tone to the underside of the overlapping petals. The centre, with its darker-toned pink roses, was worked over with a softer HB pencil, providing definition where necessary. I added leaf strands and crystals where they appeared in the bouquet and finally put in the surrounding skeletonized leaves.

Final considerations

Once you are satisfied with a drawing, you need to make a few final decisions about your presentation. The question of whether to sign the drawing and, if so, where your signature should go sometimes causes as much difficulty for the beginner as finishing the artwork itself. Getting to the point at which you consider your artwork is worth displaying can be a tense time and you may feel a lot of uncertainty about this big step.

A signature should become part of the artwork. I have even used my signature in the negative space as part of the composition. It's a good idea to practise your signature on a spare piece of paper before placing it on your artwork. I suggest using pencil, as grey tones are preferable to black ink. Be proud of what you have achieved and never undersell your work just for the pleasure of seeing a red dot beside it!

Mounting and framing

The mount and frame should complement your artwork rather than command the viewer's attention. I usually have my mounts cut with a good-sized border, about 7.5cm (3in) on three sides, with the bottom side one-third deeper. Sometimes, with a larger drawing, I prefer a 10cm (4in) mount with the bottom slightly deeper. I generally match the colour of the mountboard with the drawing paper, so there is minimal chance of distracting the eye from the image. I always use conservation, acid-free mountboard, as cheaper boards start to yellow over time and can affect the artwork.

While the choice of mounts and frames is a personal one, do bear in mind when exhibiting your artwork that it has to appeal to a large audience, so something neutral may be best. For framing, a plain wood moulding such as oak or ash is a popular choice as it looks attractive without distracting the viewer from the artwork. For some exhibitions, such as those held by the Society of Botanical Artists in the UK, there are strict guidelines on framing. Paintings will be refused if the frames are not as required, as many paintings are sold for a great amount of money and substandard frames detract from the visual quality of the exhibition. Your best option is to find a good framer, who can advise you on choice.

Looking for inspiration

Exhibitions are an excellent source of inspiration for different ways of drawing plants and flowers. Initially I was exposed to the wonderful talents of the artists at botanical art shows at the Royal Horticultural Halls in London, where exhibitors are awarded medals of merit. The Society of Botanical Artists' exhibition in London is also a feast of superb botanical paintings – you will find details of exhibitions on their website, www. soc-botanical-artists.org. The American Society of Botanical Artists also have exhibitions and wonderful pieces of art; explore their website at www.asba-art.org for information on exhibitions and artists.

The Shirley Sherwood Gallery of Botanical Art, which opened at Kew Gardens, London, in April 2008, is the only continuously open gallery in the world dedicated solely to botanical art. It holds regular exhibitions throughout the year, featuring historic and contemporary botanical illustrations. Books by Shirley Sherwood contain contemporary botanical paintings and drawings from her collection and are also an excellent way of stimulating the imagination.

There are numerous artists I could name who have been a personal inspiration. They include Pandora Sellers, for her wonderful compositions of overlapping leaves and plants. I was fortunate to meet Pandora at college when studying botanical illustration, and I remember her saying she sometimes took three months to paint just one leaf. Looking at the quality and expertise of her work, this is not surprising.

Kate Nessler is an inspiration for her simplicity of design; her paintings on vellum incorporate fresh blooms with decaying matter. Ann Swan has done groundbreaking work in gaining acceptance of the use of coloured pencils in the botanical art world. Her combination of graphite and coloured pencil is particularly delightful and her exceptional talent has taken composition to a new level. Rosie Sanders is another notable artist. I first discovered Rosie's work at the Jonathan Cooper Gallery in Fulham, London, and she has been a constant source of inspiration ever since.

Early flower drawings were more a record of the plant or flower and had no room for artistic interpretation; this came into play at a much later date, around the 18th century. Belgian botanist Pierre-Joseph Redouté (1759–1840) was one of the most well-known and prolific artists of his time, famed in particular for his beautiful paintings of roses.

Another botanical artist whose work I particularly admire is Sarah-Ann Drake (1803–57). Unfortunately little is known about this artist. She was trained by the distinguished British botanist John Lindley to create drawings from plants that had been sent to him from around the world. I have always thought her combination of neutral greys and splashes of colour to be far ahead of its time, particularly her studies showing the orchid *Calanthe versicolor* in *Treasures of Botanical Art* by Shirley Sherwood and Martyn Rix, and the orchid *Orchis maderensis* in *The Art of Botanical Illustration* by Wilfred Blunt and William T. Stearn.

Whatever or whoever fuels your excitement for flower drawing, my final piece of advice is always to remember what a huge advantage it is to have a love and passion for your subject of study.

Index